IMAGES
of America

THE SAN RAFAEL
SWELL

IMAGES
of America

THE SAN RAFAEL
SWELL

The Emery County Archives

ARCADIA
PUBLISHING

Published by Arcadia Publishing
Charleston SC, Chicago IL, Portsmouth NH, San Francisco CA

Printed in the United States of America

Library of Congress Catalog Card Number: 2007935835

For all general information contact Arcadia Publishing at:
Telephone 843-853-2070
Fax 843-853-0044
E-mail sales@arcadiapublishing.com
For customer service and orders:
Toll-Free 1-888-313-2665

Visit us on the Internet at www.arcadiapublishing.com

This book is dedicated to the wonderful men and women of Emery County who have discovered the treasures of the San Rafael Swell and so willingly shared with me for this book.

CONTENTS

ACKNOWLEDGMENTS

The greatest amount of thanks for this book naturally goes to photographers, who have allowed us to see the San Rafael Swell and surrounding area through their lenses, capturing what they thought was interesting and important. Every photograph is a precious piece of history. I am especially appreciative of those who stepped forward and generously shared their photographic collections. Their names will be seen repeatedly in the courtesy lines herein.

I owe a special thank you to my husband, Ben Grimes, a professional photographer with a particular fondness for the San Rafael Swell, who so willingly volunteered his time to mend many old photographs and make them useable in this project as well as allowing many of his photographs to complete this book.

Emery County Archives has collected many oral histories from residents in this area, and these are an incredible resource for our county. Much of the text that makes up these captions has been drawn from these wonderful people.

I am very grateful for the funding offered by the Utah Humanities Council and Utah Department of History for their grants and encouragement that have made the oral history collections possible, as well as helping produce this book.

My supervisor, Dixie Swasey, is the greatest! She is very supportive in this, as in all my endeavors, and has allowed me to rearrange my work schedule to accommodate the deadlines and details of this book.

And I can't say thank you enough to Trinadee Grimes and Bernice Payne, who are not only efficient and willing coworkers but great friends on whom I've leaned heavily for assistance.

I also appreciate Dr. Edward Geary's help with this book more than I can say. His knowledge and understanding of this county and its history are incomparable. He has assisted in editing the text and has guided me toward truth in the retelling of history.

There are many versions of historic events in the county, so there may be information in this book that differs with the knowledge others have. If the reader finds any discrepancies, Emery County Archives would love to hear them. We are trying to preserve all angles of history.

—Dottie Grimes
Archives Administrator

INTRODUCTION

The San Rafael Swell (the Swell) is a natural wonderland that covers approximately half of Emery County, Utah. Located in the southeastern part of Utah, the Swell is so rugged and remote that it was one of the last areas of the United States to be surveyed. This area is what geologists call an uplift or an anticline, a swelling of the earth, hence the name Swell. It was shaped like an oval bowl turned upside down, but millions of years of erosion have left it resembling great castles, towers, and monuments, along with deep canyons. Some of the canyons are so narrow a person can touch each wall at the same time, and some so wide one needs binoculars to see the other side clearly. The variety contained in its 2,000 square miles is endless.

Two distinct prehistoric human cultures inhabited the San Rafael Swell: the Desert Archaic Culture, from approximately 8,000 B.C. to 400 A.D., and the Fremont Culture, from approximately 400 A.D. to around 1300 A.D. The mysterious Desert Archaic peoples left very little record of their culture in the Swell, primarily painted figures on the canyon walls, but little else to mark their 8,000-year history. The Fremont peoples, on the other hand, left a lot of rock art as well as a rich collection of artifacts and dwellings that we can study and analyze.

Emery County was the last part of Utah to be colonized under the direction of Mormon leader Brigham Young. People living in the fertile valleys of San Pete County were asked to go east over the mountain and build settlements in Castle Valley, a name given to the area by explorers and surveyors that passed through the area and saw "castles in the distance." Orange Seely was the leader of the first group of men who crossed the mountain, with large herds of livestock, cutting a road through the canyon as they came. They assessed the area, built dugouts in the hills for homes, and went back for their families, returning the following spring. It was likely hardest on the women who had to leave their comfortable homes and green acres to start all over again in such lowly circumstances: keeping house in a dugout. Records show that one of the ladies complained about having to live like a prairie dog, but Hannah Olsen Seely's words said it all: "Damn the man who would bring a woman to such a God-forsaken place!" But even she settled in and tamed the desert with the rest of them.

Four major streams carry water from the mountain on the western border of Emery County into the valley. Huntington Creek, Cottonwood Creek, Ferron Creek, and Muddy Creek had settlements spring up along their banks. There are currently 10 towns just west and north of the San Rafael Swell: Elmo, Cleveland, Huntington, Lawrence, Castle Dale, Orangeville, Molen, Clawson, Ferron, and Emery. The town of Green River is located in the southeastern part of the county on the banks of the Green River.

Green River was not settled by Mormon colonizers; it began as a natural place to settle as it was the only part of the river that was calm enough to cross. Green River Crossing, as it was called, was part of the Spanish Trail and also saw the explorers, surveyors, Native Americans, mountain men, and outlaws pass through the area. It began like other frontier towns and had the Wild West scenes played out on its streets: fighting, drinking, shooting, robbing, and killing.

It is all there in its colorful history. When the Denver and Rio Grande Railroad Company took their tracks across the river, Green River became a boom town.

With the settlements came the need for rangeland, and the San Rafael Swell contained a lot of it. Sheepherders and cowboys began discovering treasures of history that had been hidden for centuries. Remnants of ancient cultures were scattered all through the Swell. Fossils of sea creatures and plants; dinosaur bones and dinosaur footprints in the sandstone; deep canyons, caves, arches, and miles of a jagged, almost vertical rock; desert bighorn sheep, antelope, wild horses, and burros; silver, gold, marble, copper, and uranium were part of this amazing area that locals simply refer to as "The Desert." The Swell and all of its resources factored into the way of life in Emery County.

Early cowboys took large herds of sheep, cattle, and horses to the desert and some built cabins and tried living there for a while: the Swaseys, Hambricks, and Warehams, to name a few. The Swaseys and the Warehams added their horses to the wild horses that were there and made a living rounding them up and selling them. Cabins, watering troughs, and corrals can still be found in the Swell from the early cowboy days. In the early 1900s, Emery County residents began celebrating the Easter holiday in the desert. This became a tradition, and the word "Eastering" was added to the local vocabulary, meaning that Easter weekend would be spent on the desert.

The San Rafael Swell seemed to offer all sorts of minerals, but as mining operations for one thing or another got underway, the source would end before producing enough to be commercially valuable. Then came the uranium boom of the 1950s. The Swell became a productive hot spot for prospectors, and thousands of uranium claims were filed. For the next decade, there was a lot of activity. Prospecting and mining required hundreds of miles of roads to be built in extremely rugged terrain. During this same time period, the federal government contracted with Morrison Knudson to construct tunnels in the Swell. Rumors flew around Emery County that the government was going to build some storage caves for ammunition, but many speculated about more covert possibilities because of the cold war. However, the sandstone strata failed the blasting tests, and so the work came to a halt and the mysterious project was abandoned.

The diverse geology, the dinosaurs, the ancient Native American inhabitants, and the more recent pioneer settlers all left their records in the San Rafael Swell, making it a place of fascination and wonder. This book is an attempt to present a glimpse of the Swell to those who have not experienced it and an effort to preserve memories for those who have.

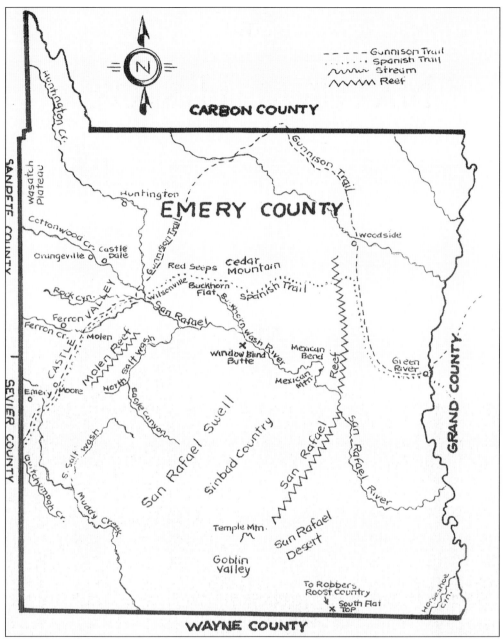

Emery County is one of the largest counties in the state of Utah. There are no cities in the county, but 11 small towns. Most of the towns are scattered along Highway 10, which runs diagonally across the northwest corner of the county. Green River is located on the eastern border of the county. The center of the county is the San Rafael Swell, approximately 50 miles long and 30 miles wide and bordered on the east by the San Rafael Reef and the San Rafael Desert. (Courtesy Emery County Archives.)

One

NATURAL HISTORY

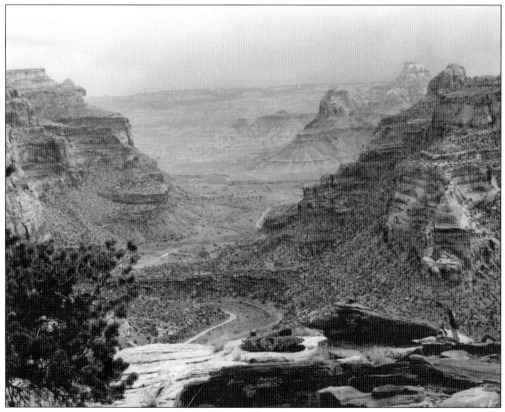

The "Little Grand Canyon of the San Rafael River" is best seen from the Wedge Overlook. The San Rafael River has carved a deep gorge through the uplifted geologic strata. (Courtesy Monte Swasey.)

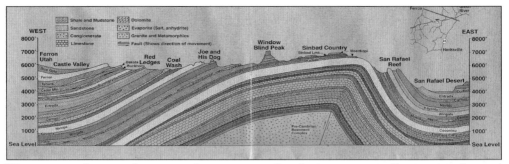

The amount of erosion has exposed many types of geologic structure, allowing it to be read by geologists as though it were a textbook telling about the creation of the San Rafael Swell. (Courtesy Emery County Archives.)

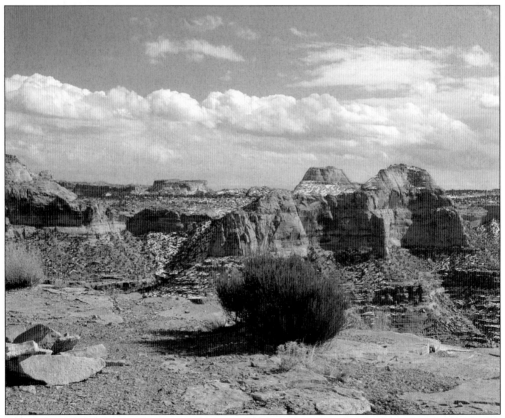

These massive sandstone formations have eroded into fantastic shapes that often resemble the grand castles of Europe and can be seen from far away by travelers, hence the name Castle Valley. But often ordinary things are spotted throughout the Swell, such as a catcher's mitt, a slipper, a lady's hat, or a beer stein. (Courtesy Ben Grimes.)

12

The San Rafael Reef is a dramatic geologic uplift running for 40 miles along the eastern border of the Swell. The Wingate sandstone formation has been tilted almost vertical, forming a jagged skyline that is visible from miles away. Colors in the Swell range from yellows, tans, and grays to brown, orange, vermilion, and burgundy. (Both courtesy Ben Grimes.)

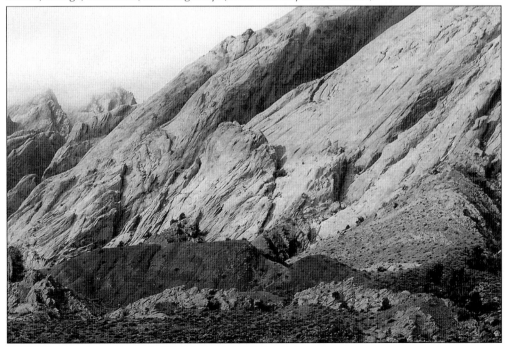

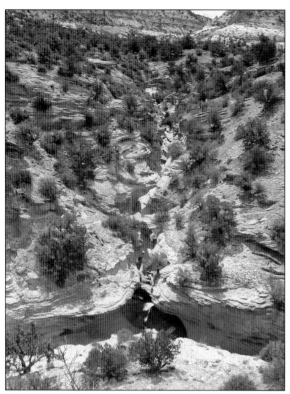

Look closely to see the crack in the landscape. Slot canyons such as this one are examples of erosion's power to cut deep pathways far below once-solid rock surfaces. Devil's Canyon is seen here with an even narrower side canyon winding to the top of the photograph. Slot canyons often make great hiking trails for the adventurous. One never is sure what might be encountered around the next bend. Some trails are easy enough for families, while others require climbing equipment and technical skills. Some slot canyons join with others and make a hiking loop, such as Ding and Dang Canyons and Little Wild Horse and Bell Canyons. Other slot canyons are Straight Canyon, Eardley Canyon, Crack Canyon, and Chute Canyon, all of which cut through the San Rafael Reef. Little Wild Horse canyon (below) is probably the most-hiked slot canyon in the Swell, and even little children enjoy this hike. (Both courtesy Ben Grimes.)

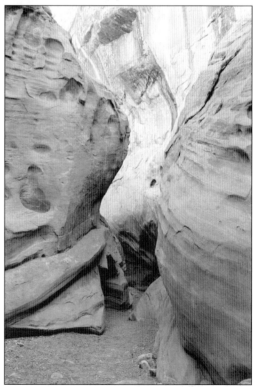

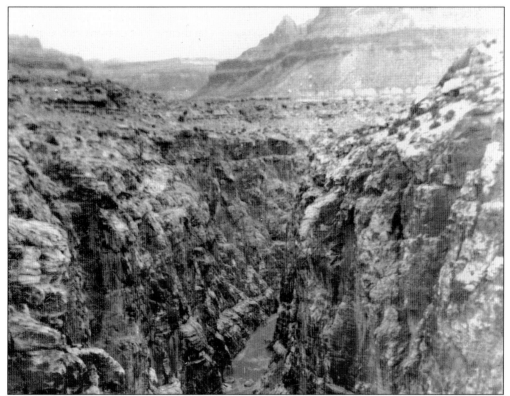

The Black Box, where the San Rafael River has cut a narrow gorge into the Coconino sandstone formation (the oldest exposed rock in the Swell), is impassable during high water seasons, but a few adventurous hikers make their way through when the water is low by wading, swimming, and scrambling over rock falls. (Courtesy James Nielson.)

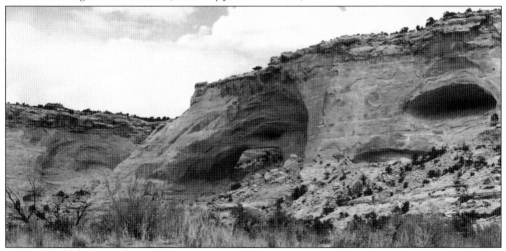

There are several arches in the Swell that resemble items people use in everyday life, such as the one shown above. It is named Slipper Arch. It looks like a high-heeled shoe, with the heel on the right side of the arch and the rest of the shoe on the left. This can be seen from the road, and there is a large open area around the arch, making it a great camping place as well as good for climbing or hiking. (Courtesy Owen Price.)

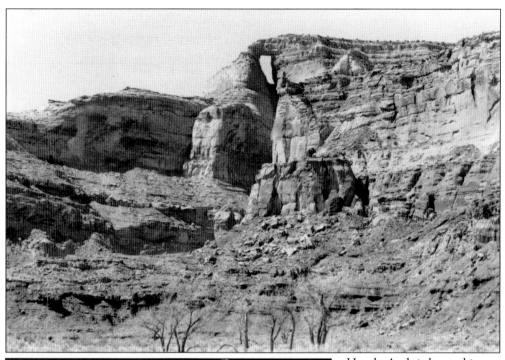

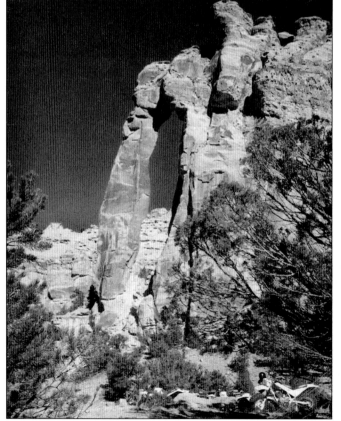

Hondu Arch is located in the Muddy River Gorge area in the southern part of the Swell. The arch was named for its resemblance to the loop-like knot on a cowboy's lariat that allows the loop to slip open and closed. The knot is called a "hondu," sometimes pronounced "hondo." (Courtesy Mark H. Williams.)

Eagle Arch, found in Eagle Canyon, is one of those formations that remind us of everyday things; this arch is often called "Beer Stein Rock." (Courtesy Mar Grange.)

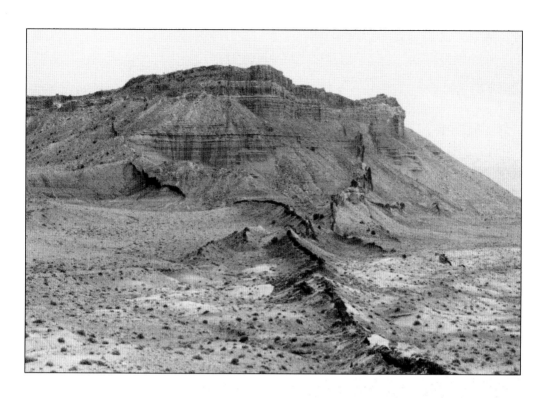

Molten rock was forced by great pressure from far below up through cracks in the overlying strata. After eons of erosion, the molten rock, now solidified and harder than the surrounding rocks, is exposed in long, wall-like formations. (Above, courtesy Mar Grange; below, courtesy USGS.)

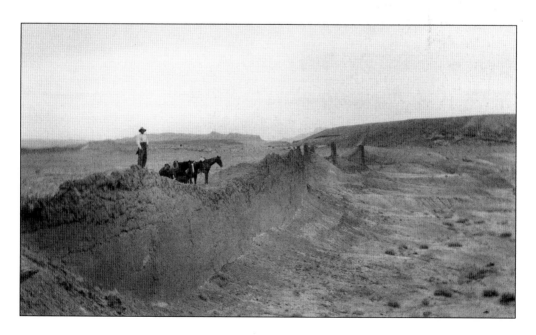

This break in the sandstone wall at a high elevation of the Swell is called the Window. From this dangerous overlook, there is a vertical drop of more than 1,000 feet into Reds Canyon below. (Courtesy Mar Grange.)

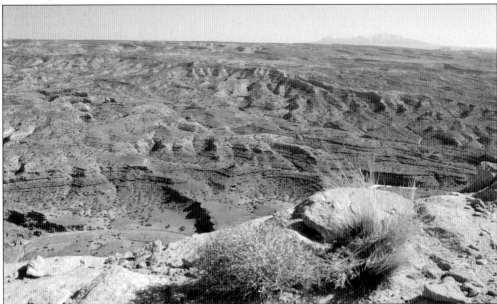

The dark, red badlands known as Reds Canyon are seen far below from a viewpoint near the Window. The Henry Mountains are visible in the distance. (Courtesy Ben Grimes.)

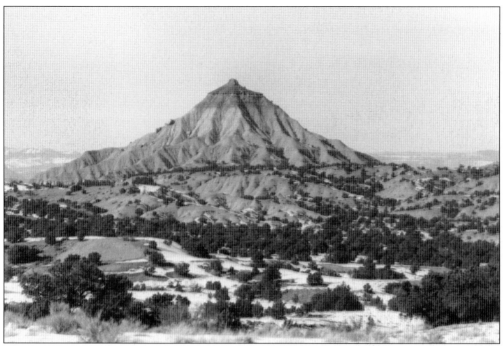

This formation is known as the Wickiup because it resembles a Native American teepee-like dwelling. It stands alone and can be seen from many parts of the Swell. (Courtesy Mark H. Williams.)

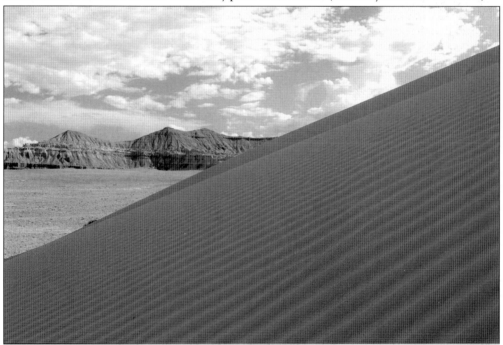

The gigantic Mussentuchit Sand Dune is located near the southwest corner of the Swell, adding one more texture to the geologic diversity of the area. The large sand dune is another playground area. One can climb up, slide down, dig in the sand, or just watch the tracks being made by little bugs and lizards who reside in the desert. (Courtesy Ben Grimes.)

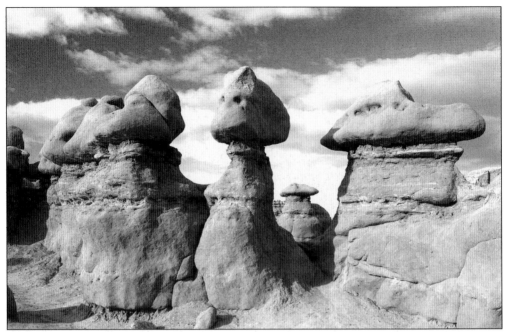

Hoodoos eroded from red Entrada sandstone are found in Goblin Valley State Park. One may wander, run, or climb on any of the weird creatures that stand in this valley. Historically it was first known as Mushroom Valley, then Goblin Valley, and in later years has been referred to as the Alien Landing, but whatever the name, it is unlike any other place on earth and makes a perfect playground for the young at heart. (Courtesy Ben Grimes.)

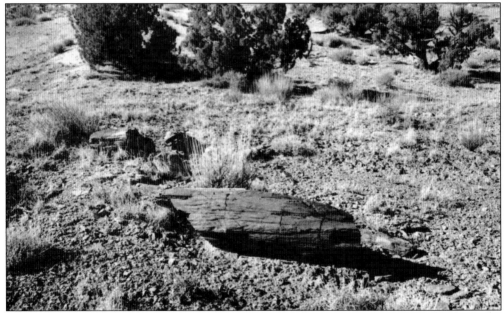

Petrified wood is found in many places on the Swell. The abundant fossil record in the San Rafael Swell indicates that the landscape then included forests of sequoia and other large trees and shallow lakes filled with freshwater mollusks. Dinosaurs roamed the plain, including the Allosaurus, found in large numbers at the Cleveland-Lloyd Quarry. (Courtesy Mar Grange.)

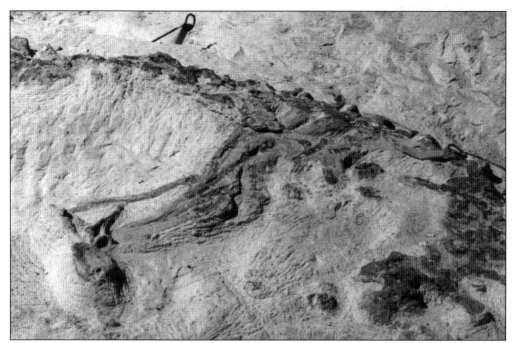

On the Bureau of Land Management Web site, it says, "There in the black mudstone beneath your feet, black bones are visible. Bones of creatures who once ruled the Earth but died in fear, pain, and exhaustion are preserved by the geologic processes of fossilization." (Courtesy Monte Swasey.)

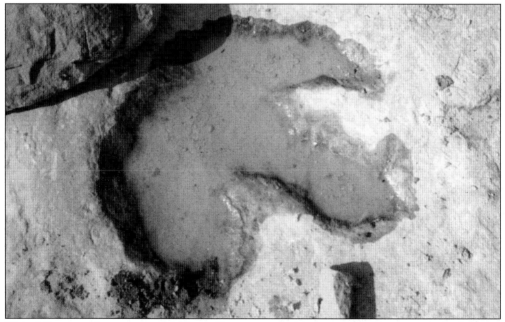

This Allosaurus footprint in Buckhorn Draw is a tourist attraction. There are many dinosaur tracks found in the Swell; some are even pathways of tracks, but none are quite as obvious as this one. Dinosaur fossils from the Jurassic Period are abundant in the San Rafael area. The Cleveland-Lloyd Quarry has yielded more Allosaurus specimens than any comparable site in the world. (Courtesy Monte Swasey.)

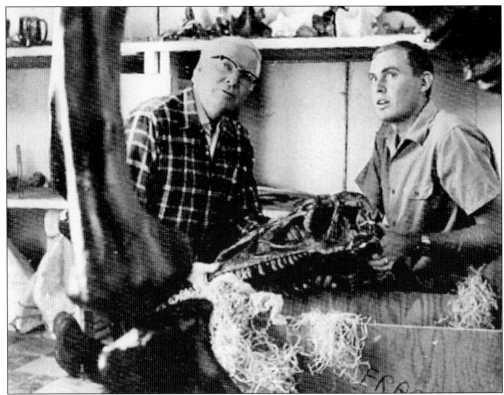

William Lee Stokes, professor of geology at the University of Utah, is working with a student assembling a dinosaur skeleton. Stokes grew up in Cleveland, Utah, and reportedly discovered the fossil cache that became the Cleveland-Lloyd Quarry while herding livestock as a boy. He led the Princeton University excavation of the site in 1939–1941. Eight species of dinosaurs are named for him, and he discovered and named 13 rock formations in Utah. (Courtesy Utah State Historical Society.)

Malcomb Lloyd provided the funding for the Princeton excavation led by Lee Stokes. The quarry and museum were given the name Cleveland-Lloyd: Cleveland for its nearness to Lee Stokes's hometown, and Lloyd after Malcomb Lloyd and his generous interest in the area. It contains the densest concentration of Jurassic fossils ever found. How the dinosaurs ended up in the area is a mystery. It appears as though many dinosaurs died and someone or something stirred all of the bones. Full skeletons are found, but the bones are scattered throughout the area. No one has been able to solve this puzzle yet. (Courtesy Utah State Historical Society.)

The Bureau of Land Management Web site explains that fossilization of the bones happens when "groundwater passes through them, trading inorganic minerals for organic marrow. The slow accumulation of thousands of feet of sediment . . . Seas cover the land and then retreat. The Earth's crust shifts and the San Rafael Swell starts to form. . . . With that swelling comes erosion. The thousands of feet of sediment disappear and one day a sheepherder stumbles across a large black bone. . . . Pretty sure it isn't a sheep bone, he tells his friends. Word eventually finds its way to academia and the hunt for dinosaurs reaches Emery County. Seventy years later people are still coming here in amazement and awe to look upon the remains of vanished giants." (Both courtesy Cleveland Lloyd Dinosaur Quarry.)

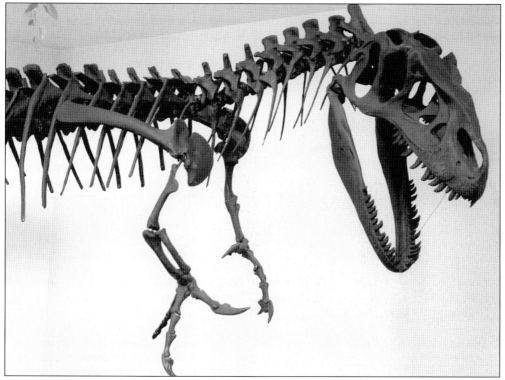

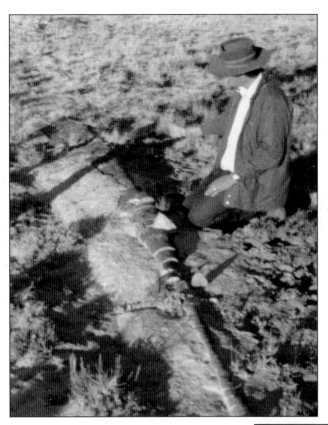

Owen Price spent weeks at a time on the Swell building roads for ranchers and miners. He discovered many things of interest, including this large fossil he called "the Monster," which seems to be a large alligator-type lizard. Don Burge, renowned in the field of geology and paleontology, is examining Price's "Monster" fossil. Burge came to Castle Valley as a young man to teach at the College of Eastern Utah. He became acquainted with a group of rock hounds known as the Castle Valley Gem Society, many of whom became his students at a night class he taught. One night after class, he remarked that Eastern Utah was the greatest dinosaur bone yard in the world, but they didn't even have a museum. He encouraged them to establish a museum. (Courtesy Owen Price.)

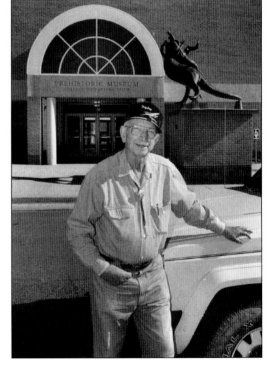

Dr. Eldon Dorman was a physician in Price, Utah, when Don Burge began teaching geology classes. As part of the Castle Valley Gem Society, Dr. Dorman was inspired by Burge to begin a museum with the help of others of the society. Burge suggested they all go through their basements and gather all gemstones, dinosaur bones, and other discoveries they had made and collected and combine them into a museum. This was the beginning of the College of Eastern Utah Prehistoric Museum. (Courtesy Maurine Dorman.)

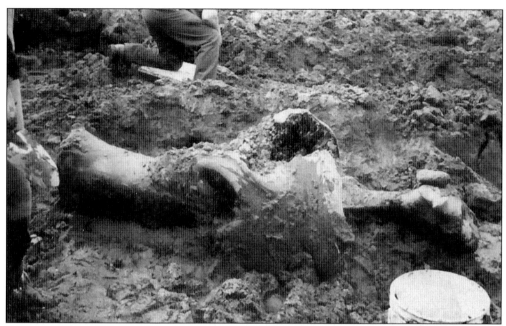

Dinosaurs are not the only giants that lived in Castle Valley. In the mountains near the San Rafael Swell, a large earth-moving machine uncovered a giant bone while working on a dam site. Work was stopped as the proper agencies were contacted. A Columbian mammoth was uncovered, not fossilized but well preserved in dense, cold mud, which prevented decay of the bones and even preserved some of the animal's stomach contents. Columbian mammoths are not rare, but never had one been found at the elevation of 10,000 feet above sea level. (Courtesy Vernell Rowley.)

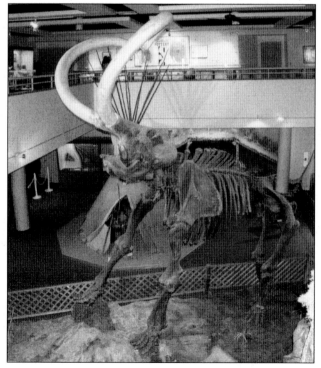

Experts believe the mammoth got caught in a muddy bog and died 11,500 years ago. Because the bones were not fossilized, recovery work had to be done quickly. Museum officials and volunteers worked with the Forest Service, Utah State archeologists, and the Huntington Cleveland Irrigation Company (who had been working on the dam) and recovered 98 percent of the mammoth. The bones are stored in a special environment to protect them since they were not fossilized. A cast of the reconstructed Columbian mammoth now stands in the Prehistoric Museum in Price. This animal likely roamed the San Rafael Swell more than 11,000 years ago. (Courtesy Ben Grimes.)

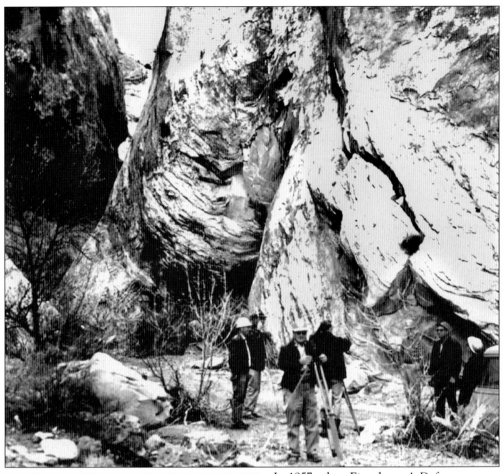

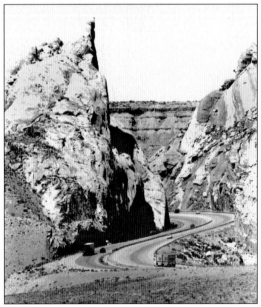

In 1957, when Eisenhower's Defense Highway System was being built to connect the whole nation, another highway was suggested to connect Denver to Utah's metropolitan area. The route chosen went through the middle of the San Rafael Swell. The name was changed to the Interstate Highway system, and this route was designated as Interstate 70. It is probably the most scenic piece of the nation's freeway system and also the longest stretch without any services. This route was surveyed in 1963 at Spotted Wolf Canyon (above), where a natural opening of a few feet was widened to accommodate a four-lane freeway as seen in the photograph at left. The highway through the San Rafael Swell was completed and opened to the public in 1970, and there are several pull-out scenic viewpoints along the way. (Both courtesy Emery County Commission Office.)

Two

A VIRTUAL ROCK
ART MUSEUM

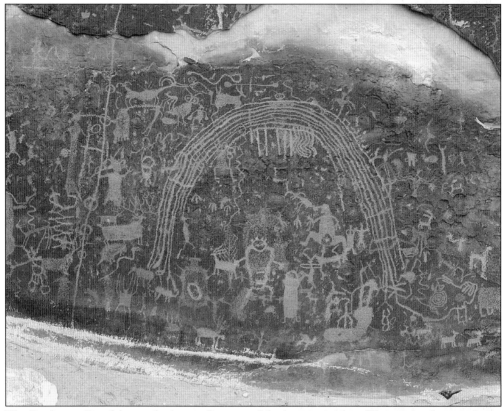

The Rochester Panel (petroglyph panel) is one of the best examples of Fremont culture rock art, dating back at least to 1300 A.D. In his book *History of Emery County*, Edward Geary says, "Emery County is a virtual museum of prehistoric rock art, with many fine examples of both petroglyphs (etched into the rock) and pictographs (drawn or painted on the rock surface). Most of these are thought to be products of the Fremont culture. There was a distinctive San Rafael art style just as there were distinctive architectural styles. Fremont rock art panels typically incorporate anthropomorphs (human-like figures) sometimes wearing what appears to be ceremonial costume; zoomorphs (animal-like figures), . . . and abstract figures, including circles, concentric circles, rainbow arcs, and wavy lines. Occasionally a humped-backed flute player appears, resembling the Kokopeli figure of the Hopi." (Courtesy Ben Grimes.)

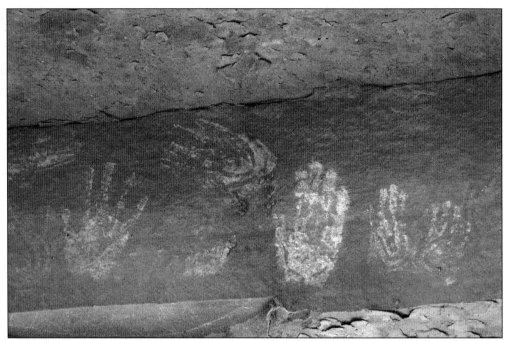

Handprints of the original Fremont Indian artists are fairly common. These handprints were made sometime between 500 A.D. and 1300 A.D. (Courtesy Ben Grimes.)

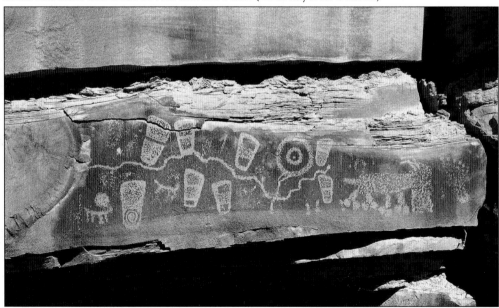

These sandal prints have been etched into the rock at Molen Seep on the western edge of the Swell. The geometric sandal prints are fairly common in Fremont rock art. Right and left sandal prints can be seen showing various patterns, which may be representations of the weaving patterns used to make the sandal's soles. One woven plant-fiber sandal found in Utah was woven with a lightening bolt pattern in its bottom, which would have left that design in the sand or mud. In this panel, beyond the desert bighorn sheep on the far right of the photograph is a pictograph of a bare foot. (Courtesy Mervin Miles.)

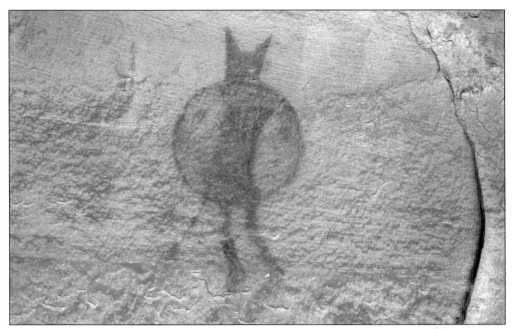

This pictograph, at the Head of Sinbad, is often called "The Lone Warrior," or a guardian warrior. A Native American shaman said these were placed in visible locations close to where they were making a home or village. There are several throughout the San Rafael. Because of its sinister appearance, earlier cowboys reportedly named it "The Devil Over Sinbad." (Courtesy Ben Grimes.)

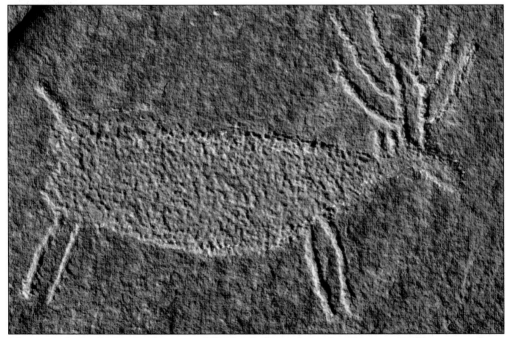

This petroglyph of a deer has been carefully chiseled into the rock and is typical of Fremont rock art. Many deer are still plentiful in the higher elevations of the Swell, especially in the winter, including Cedar Mountain, Little Cedar Mountain, and Sid's Mountain. (Courtesy Ben Grimes.)

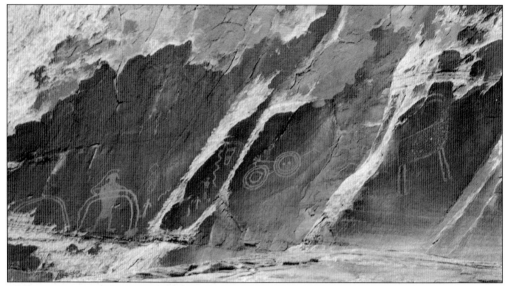

This Fremont petroglyph panel shows some of the classic Fremont figures: the desert bighorn sheep, snakes, concentric circles, rainbows, footprints, and human figures. These artists have made interesting use of the flat panels in this area. This shows how petroglyphs are usually carved into the dark patina on the rocks known as "desert varnish." (Courtesy Mar Grange.)

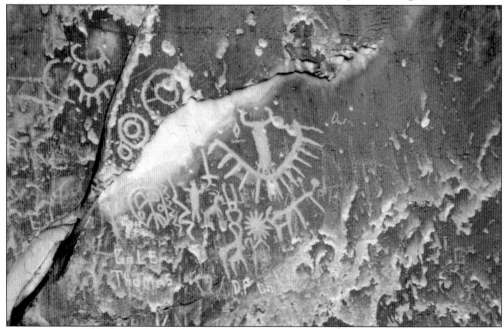

This is an example of another rock art site crowded with figures and designs. It is located in Ferron Canyon. Many types of figures are represented in the panel, including geometric figures and a human with fingers on both hands. A starburst figure may represent a supernova in the year 1054 in the Crab Nebula that the Fremont may have witnessed and recorded. Other possibilities for starburst figures include representations of the sun or moon. Historic names added to the Fremont Indian art sites at later periods are considered graffiti, and it is illegal to make marks on any rock art now. (Courtesy Mervin Miles.)

Horseshoe Canyon at the eastern edge of the San Rafael Swell contains the rock art that set the type for Desert Archaic Culture rock art known as the Barrier Canyon style. This figure is one of the most elaborate in the large Great Gallery Panel. The figure was very artistically painted and etched and stands approximately six feet tall. Barrier Canyon–style rock art with etching after the painting was done is not considered to be partly petroglyph style; rather it is in the pictograph style since the primary designs were made with paint or pigments. (Courtesy Ben Grimes.)

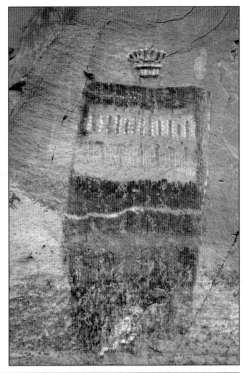

These figures are a part of the Great Gallery Panel in Horseshoe Canyon. The ghostly figure and his partners are often referred to as the "Holy Ghost and Attendants." The Holy Ghost figure stands approximately eight feet tall and was primarily created by spraying the pigment onto the rock through a reed stem or some other technique. (Courtesy Ben Grimes.)

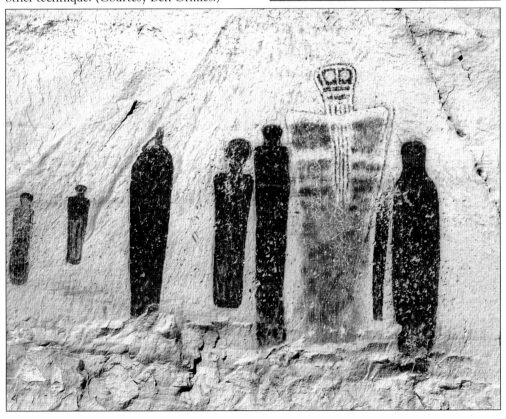

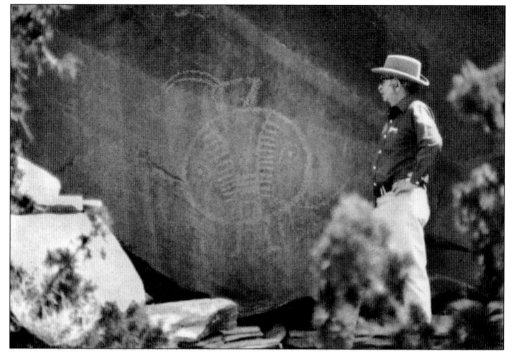

Dr. Eldon Dorman is pictured here with rock art he discovered. After he helped establish the College of Eastern Utah Prehistoric Museum, he realized they needed someone who knew about archeology, so he taught himself from books and learned from the ranchers and sheepherders where many of the rock art sites are located. He also went on two-week safaris, as he called them, twice a year to study and explore. He named this figure "Silent Sentinel" because it seems to be standing guard over the Swell so silently that it remained unnoticed for centuries. This is another of the guardian warriors standing alone with no other art around it. Dr. Dorman adopted this design; had it made up into a stained-glass window, jewelry, and many other pieces of artwork; and used it as his logo for business cards. (Courtesy Maurine Dorman.)

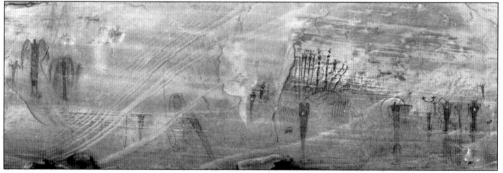

The Buckhorn Panel is one of the largest and most impressive panels of rock art in the San Rafael area. The figures are Barrier Canyon style and may date back as many as 8,000 years. The largest figures stand nearly six feet tall. The figures on the left that seem to have wings are known are "Rain Bringers" or "Rain Angels." They seem to have rain falling from their wings, or arms. The center figure has smaller drawings above it that represent a bird-hunting party. The white dots in the chests of many of the figures may be chipping done by later Native Americans, who believe that if one takes chippings from the area of their strength and places it in a medicine bag, one will acquire their "good heart" or "courage" or other qualities. (Courtesy Ben Grimes.)

This Ferron Box pictograph is one of the most intricate and artistic Fremont panels. It is also one of the most colorful, having some protection from the elements in the box canyon where it is located. (Courtesy Ben Grimes.)

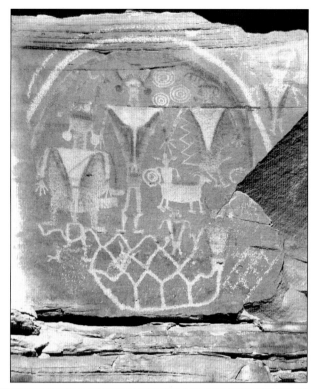

Two brothers, Ashley and Sam Grimes, recently found this leather bag near the Barrier Canyon pictograph panel called the Great Gallery. They notified the ranger, who collected it. Archeologists have tested and analyzed it and found that it contains marsh elder seeds in the lower half and a tool kit for making small arrowheads in the upper half of the bag. It is dated to around 1300 A.D. This is an example of how time continues to uncover treasures from the past in the San Rafael Swell. (Courtesy Ben Grimes.)

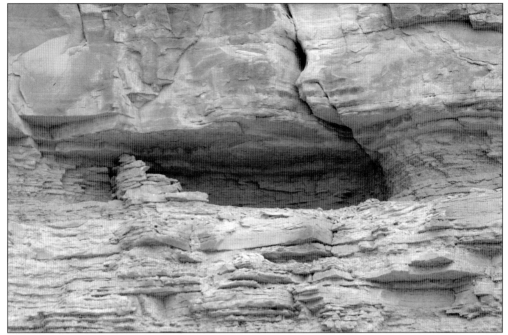

What appear to be cliff dwellings in the San Rafael Swell are believed to be storage rooms or granaries from the Fremont culture. This one is located high in the cliffs near the rock formations of Sid and Charley. (Courtesy Ben Grimes.)

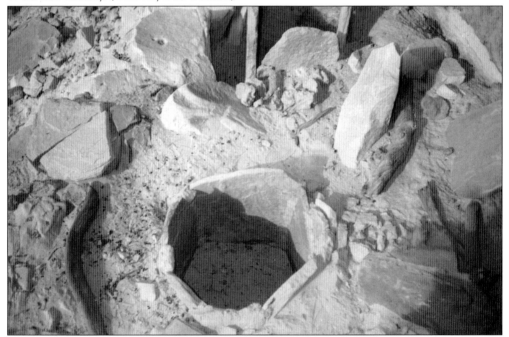

Mervin Miles, as an employee of the Bureau of Land Management, spent 40 years on the San Rafael Swell. In that time, he discovered many sites where remnants of the ancient cultures still exist. This is one of the many granaries built by the Fremont people to store their grains and other food items. (Courtesy Mervin Miles.)

Three

THE OLD SPANISH TRAIL

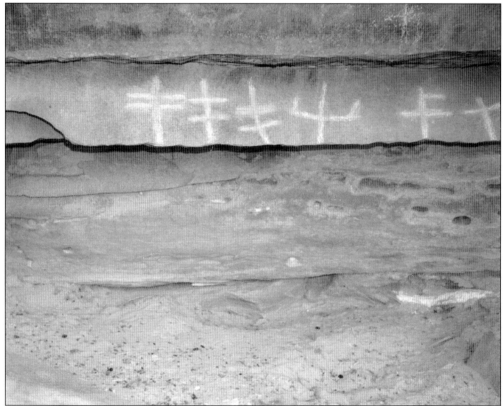

Spanish crosses or markings can be found on the San Rafael section of the Old Spanish Trail. It was a major highway of the 1800s, taking its travelers from Santa Fe to Los Angeles. It was used by traders leaving Santa Fe, New Mexico, with woolen goods to be traded for horses and mules. They also traded with the Native Americans for slaves to take to California. The trail went north to avoid rugged terrain and the Mohave Desert. Its northernmost point passed through the San Rafael Swell. It has been called "the longest, crookedest, most arduous trail in the country" and also "the shortest trail to treasure." (Courtesy Monte Swasey.)

The Spanish Trail entered Emery County at the Green River, crossing through Buckhorn Flat to the Red Seeps. It crossed Huntington Creek and went on to Cottonwood Creek, where Wilsonville would later be established. It followed the Rock Canyon Wash through the Molen Reef, and about a half mile east of where the Hunter Power Plant now stands, it turned south, crossed Ferron Creek at the present town of Molen, crossed the Muddy Creek two miles east of what is now the town of Emery, and then went over the Wasatch Plateau mountains through Salina Canyon. Above is one of the many signs posted along the trail, which has been designated a National Historic Trail. Below is another segment of the trail through Cottonwood Draw. The two-track road is not the trail itself, as the Old Spanish Trail was a corridor. Two thousand horses and mules and travelers would have spread out over a large area, but this is part of the pathway. (Both courtesy Owen Price.)

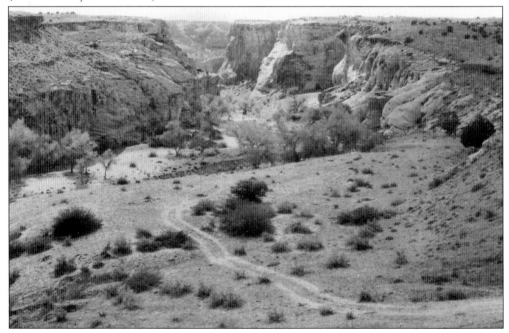

Lamont Johnson, a Denver journalist with roots in Emery County, wrote, "Long before Utah was settled, caravans of Spanish, Mexican, Indian, and American adventurers were tramping along the route of the Spanish Trail. To us it is a more cherished inheritance than the furs they trapped, or the horses they stole, or the gold they famished for. From 1800 to 1850 was the period of trading concourse over the Spanish Trail. Ute Indians traveled parts of it earlier than that; survey and military parties likewise used the route afterward. The San Rafael River is one of the many landmarks the Spaniards named as they moved through the area." (Courtesy Ben Grimes.)

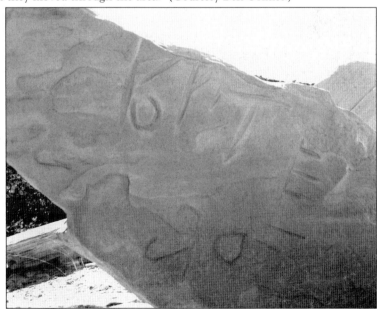

The carvings in this rock along the Old Spanish Trail are believed to be Spanish markings. There are, of course, many legends of Spaniards hiding treasure or having discovered gold mines and leaving a legend-map of sorts in order to find it again. (Courtesy Ben Grimes.)

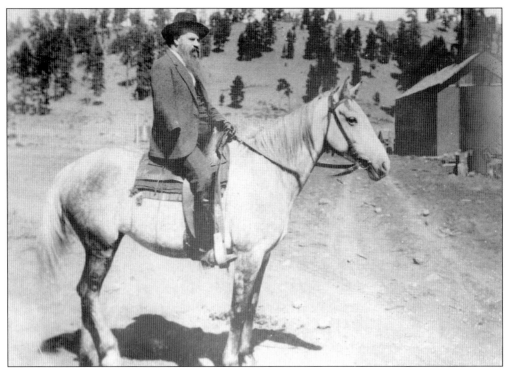

John Wesley Powell lost an arm in the Civil War but went on from there to explore the West, following the Spanish Trail. He often climbed to high points to view the entire landscape, sometimes scaling cliffs with only one arm. (Courtesy Utah State Historical Society.)

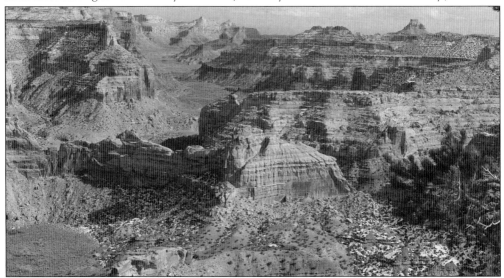

Powell wrote in his journal, "Then comes Castle Valley, to describe which is to beggar language and pall imagination. . . . In its midst is San Rafael Swell an elevation crowned with . . . gigantic rock forms . . . interrupted here and there by badland hills. . . . Among the rocks . . . little streams run in canyons that seem like chasms cleft to nadir hell." Powell's most famous expedition was a 900-mile journey on the Green and Colorado Rivers. A few years later, he conducted a second expedition. (Courtesy Ben Grimes.)

Photographed in 1871 are the second expedition members stopping at the Green River Crossing. This crossing on the Old Spanish Trail was a natural place for a town to be built. Pearl Baker describes the Green as flowing down a giant staircase where one tread stretches out and allows it to flow calmly before beginning its descent again. That "stretched out tread" is the Green River Crossing. (Courtesy Utah State Historical Society.)

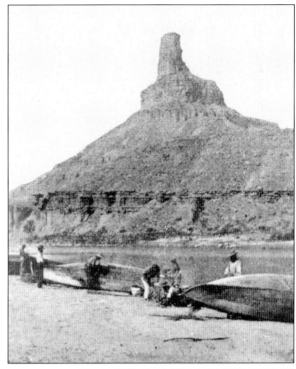

Almon Harris Thompson, a member of the Powell expedition, recorded in his daily diary that entering into the San Rafael Swell, they saw Native American teepees, but the Native Americans were gone. This photograph was taken at a Mountain Man Rendezvous, which is held somewhere in the Swell every year. (Courtesy Monte Swasey.)

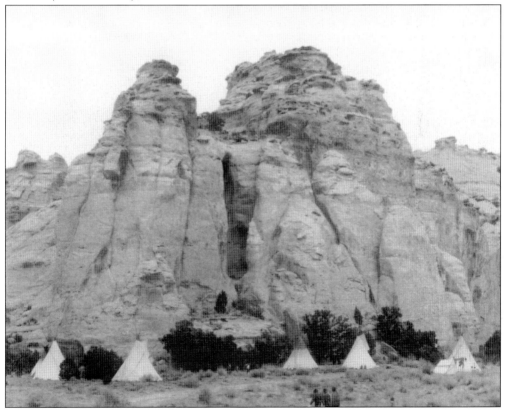

Another entry in Powell's journal says they stop at the San Rafael River, "take a short walk up the valley and find it is a beautiful resort for Indians. Arrow heads are scattered about, many of them very beautiful. Flint chips are seen strewn over the ground in great profusion, and the trails are worn." (Both courtesy Ben Grimes.)

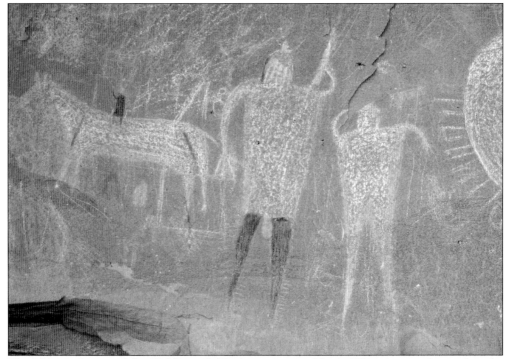

The Utes used parts of the Old Spanish Trail on a seasonal basis. This pictograph was done by the Ute Indians. Horses appear in Ute artwork but are not found in the early pieces. (Courtesy Ben Grimes.)

Lt. E. G. Beckwith came with the John Gunnison expedition in 1853 and recorded the following: "As we approached the river yesterday, the ridges . . . to the west appeared broken into a thousand forms—columns, shafts, temples, buildings, and ruined cities could be seen, or imagined, from the high points along our route." Another member of Powell's group describes it similarly: "It is an eroded valley with cliffs all around, castellated in fairy turrets, pinnacles, towers, and bastions. One butte opposite our camp is like a Gothic church spire on one end and buttresses along the side." (Above, courtesy Mark H. Williams; below, courtesy Owen Price.)

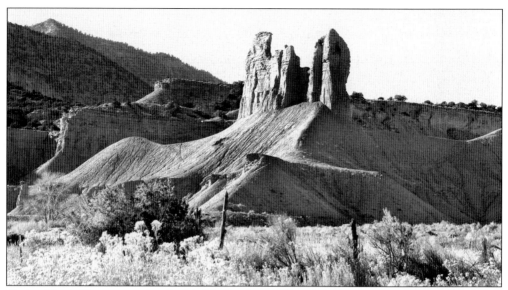

Gwinn Harris Heap stopped at the Muddy Creek in 1853 with his group of travelers and likely saw a sight similar to the one above when he wrote, "Traveled twenty miles south by west, and halted at noon on the Rio del Moro (which means Castle Creek). At times, long lines of battlements presented themselves, at others, immense Gothic cathedrals with all their quaint pinnacles and turrets, which reminded us of the ruined castles and churches that we had seen in our travels in the old world. The different colors of the clay added to the singularity of the scenery and strengthened the resemblance." (Courtesy Owen Price.)

The Denver and Rio Grande Railroad Company began building a route following a portion of the Old Spanish Trail in 1881. They completed 50 miles of the bed before they were stopped. The work, though never finished, was a boon to Emery County. A man was paid $2 a day, except for the Chinese who were paid $1.10 a day, and a man with a team of horses was paid for each horse as well. (Courtesy Ben Grimes.)

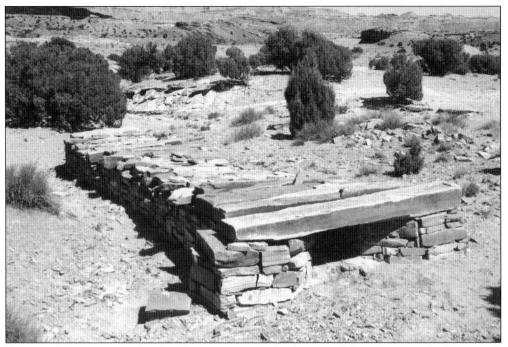

This carefully constructed rock culvert was intended to be part of the railroad grade. Since work was abandoned, this structure stands out in the open, never having been covered, just as it was left about 130 years ago. (Courtesy Mar Grange.)

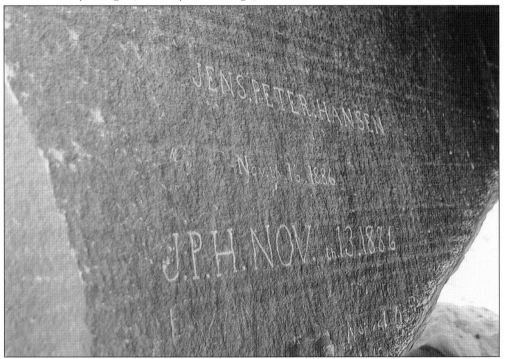

This is a part of Railroad Rock where the workers chiseled their names and dates along a forgotten piece of history. (Courtesy Mark H. Williams.)

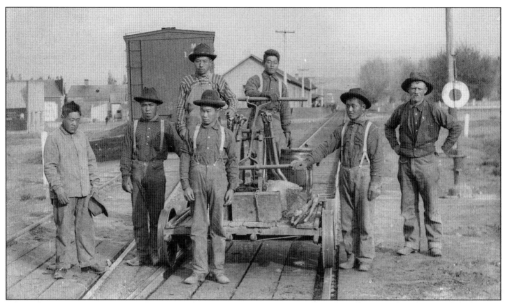

This group of railroad workers completed the railroad in Price, which was the alternative route Denver and Rio Grande was working on and the one that was completed. (Courtesy Brigham Young University, Special Collections.)

Along the hills of the abandoned route through the Swell are found remnants of rock shelters inhabited by the Chinese railroad workers. This ruin adds to the record of hardworking men who did their best work on a project that would never be finished. (Courtesy Mar Grange.)

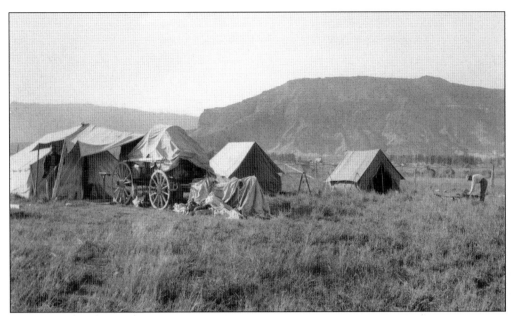

The U.S. surveyors also used the Spanish Trail as they arrived to begin their survey of the San Rafael Swell. Lucy Hansen Nielsen remembers when the surveyors camped near her town of Molen during the summers of 1909 and 1910. They joined in with the children, playing games and entertaining them. She writes, "The evidence of these surveyors' faithful work can be seen in the corner pegs with sections, numbers, and directions in the rugged country down below." (Down below refers to the Swell.) (Courtesy USGS.)

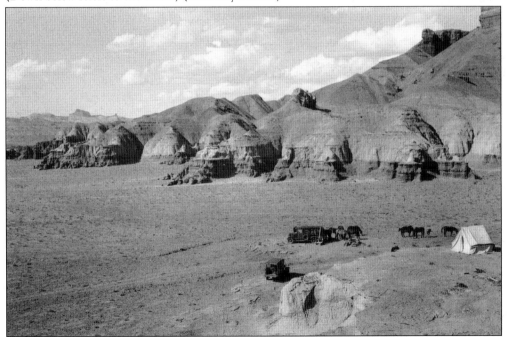

In 1935, the U.S. Geological Survey teams were using automobiles to traverse the Swell, even though there were only a few roads. Here they are seen at a camp on a bluff in Wild Horse Canyon with the automobiles down below. (Courtesy USGS.)

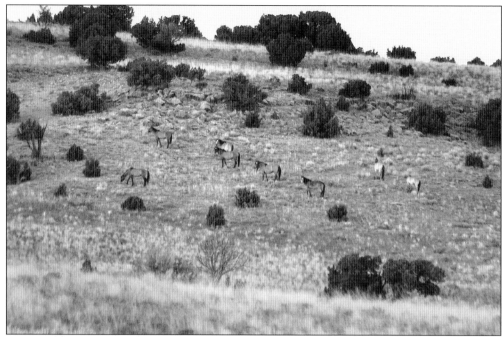

Wild horses and burros are as much a part of the San Rafael Swell as the antelope, bighorn sheep, and lizards. Legends tell that many of the horses and burros escaped along the trade route as the huge herds were being moved along. Another theory is that they are part of the horses that Ute Chief Walker stole from the Mormons and hid in the San Rafael. The last wild horse roundup was in the 1950s. After that, some horses were destroyed because herds were too large. Because of the Wild Horse and Burro Act of 1971, the herds are now protected on the San Rafael Swell. The desired number of horses for the area is around 125 and 70 for burros. Every four years, some of the animals are rounded up and sold at an auction in order to keep the numbers at a manageable level. (Both courtesy Ben Grimes.)

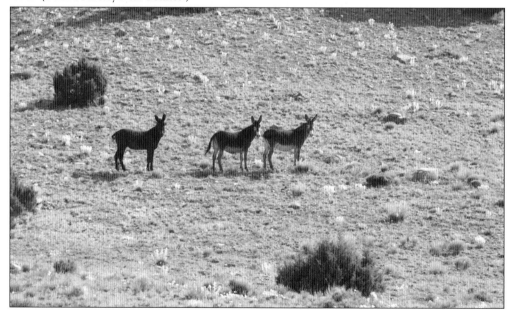

Four

WRANGLERS, RANCHERS, AND ROBBERS

The Swasey brothers went to the San Rafael Swell with the family's herds of cattle and horses in the 1870s. Liking the Swell so much, they basically made it home for many years. The Swasey boys included Charlie, Rod, Sid, and Joe. They made their living wrangling the wild horses along with their own, breaking the young ones and selling them. Their adventures and stories are embedded in the Swell as deeply as the fossils. Joe Swasey married Mary Etta McDonald in 1887. (Courtesy Swasey family.)

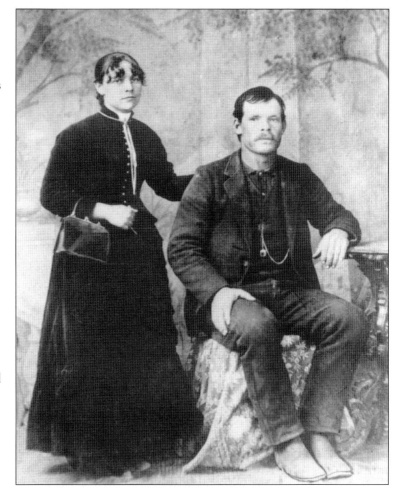

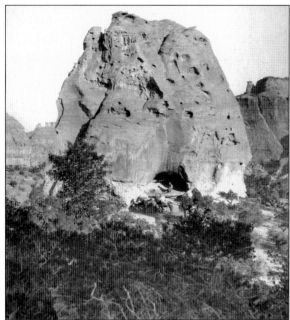

This large rock has a cozy little cave near its base that provided shelter to the Swasey brothers. The Swasey boys' stories have been passed down through the generations, until now they are inseparable from the landscape. In later years, Joe ran the horse trading business, and the cave came to be known as "Joe's Office." (Courtesy USGS.)

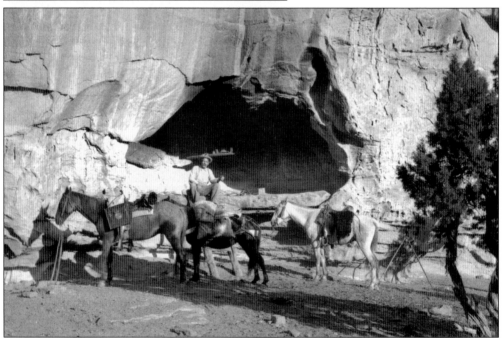

Joe Swasey is sitting in front of Joe's Office in 1911. The Swaseys and other ranchers added their horses to the wild ones. Monte Swasey said: "Granddad had 900 head of horses. And to sell these horses . . . they'd come in with maybe 100–150 head of colts, 3-years-old or so, colts from out on the desert. And they'd go through the towns . . . and trade horses, they'd trade one of these young horses for an older horse that was wore out or crippled or something. And then they'd get a little boot (anything in trade such as food or saddles) besides. They would take all of those older horses to a fish hatchery and sell them for fish food and get that pay in cash and then also have a wagon full of boot. So that's how they made their living." (Courtesy USGS.)

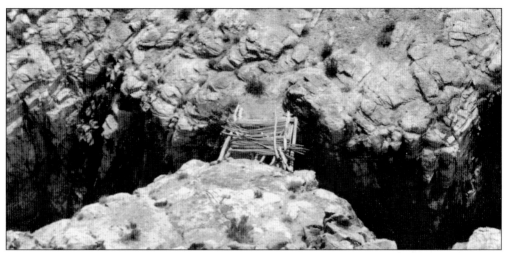

Joe's son Royal Swasey explained why some of the features of the San Rafael Swell bear the names of his father and uncles: "One day Sid and Charley were in this area, and Charley bet Sid several head of cows that he couldn't jump his horse across the chasm. Sid proceeded to jump the chasm, and won the cattle. The location is now called 'Sid's Leap.'" The San Rafael River runs through the gorge in the Upper Black Box, 85 feet below the ledge. The narrowest point at the top of the gorge is about 16 feet wide. It should be noted that Sid did not try to jump back across. As far as we know, Sid is the only one who ever attempted that feat. A wagon box was placed across the spot so that grazing land could be more easily reached; otherwise one had to go many miles to get around the gorge. The wagon bridge was later replaced with the makeshift pole bridge. Today there is no sign of the bridge. Another shot of the gorge from a different angle is seen below. (Above, courtesy Mar Grange; below, courtesy Mark H. Williams.)

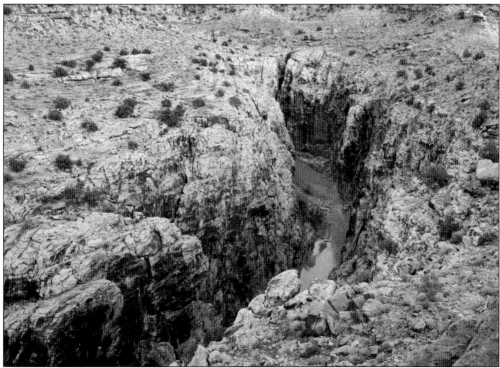

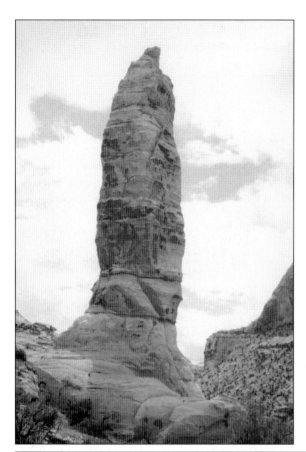

Devil's Monument is one of the many formations named after the devil. Monte Swasey, grandson of Joe Swasey, said, "I guess the only ones worse than the Swaseys was the devil, and so when they'd find a really bad place, they'd name it something after the devil: Devil's Dance Floor, Devil's Canyon, and Devil's Racetrack. Below is the Twin Priests formation seen along Devil's Racetrack. (Both courtesy Mar Grange.)

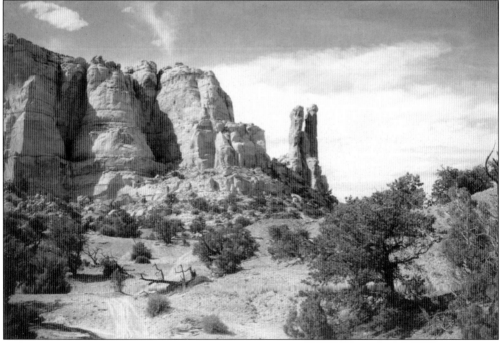

Slender Sid and hefty Charley stand like giants overlooking their old stomping grounds. Kathleen Truman, standing at the base of these Entrada sandstone formations, gives perspective of their size, which is indicative of the size of the legacy and legend they left behind. (Courtesy Kathleen Truman.)

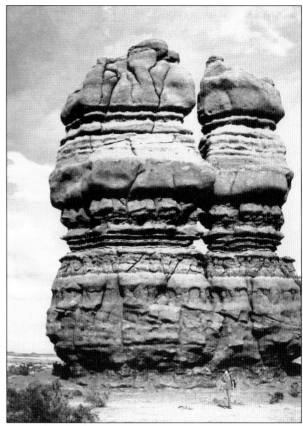

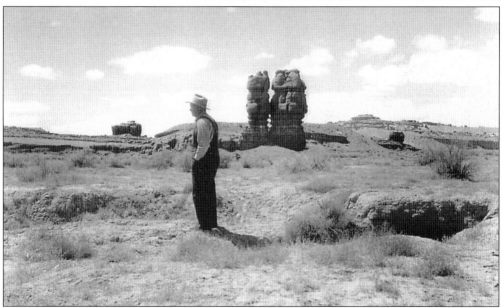

Royal Swasey is standing on the desert with Sid and Charley, the formations named after two of his uncles, in the background. They are separate formations and do not touch except at their base. (Courtesy Dixie Swasey.)

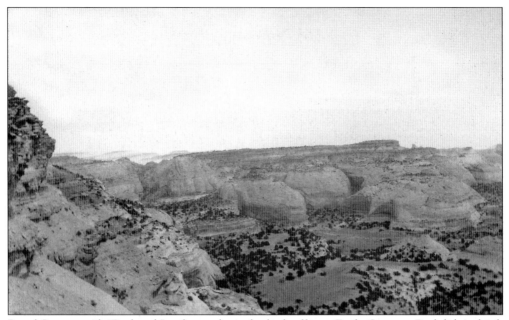

Royal Swasey said, "Rod and Joe first rode to the look-off into Eagle Canyon. Rod didn't think they could go any further, and exclaimed 'That canyon's so deep, an eagle couldn't fly out of here.'" It has been Eagle Canyon ever since. (Courtesy USGS.)

Rod Swasey is pictured here. He married Mary Ann Wayman and lived on the mountain in Joe's Valley for a while; he later settled in Castle Dale. All the boys except Sid married and settled in Emery County. Today there are many Swaseys in the area. Rod has a valley named for him on the Swell. (Courtesy Swasey family.)

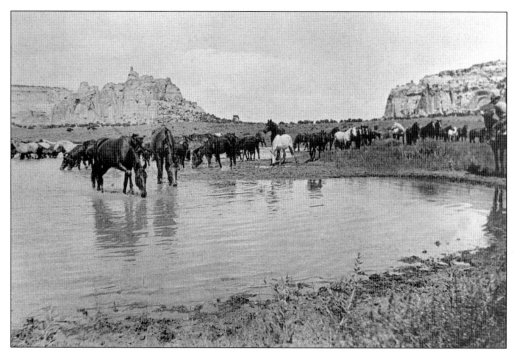

Joe Swasey continued to raise horses and cattle on the Swell. He and others put good stallions with the wild horses and raised a variety of good horses. Joe went to Pollouse Valley in Idaho and brought back many Appaloosa horses. Monte Swasey said of his father, Royal, and grandfather Joe, "They had every color and shape imaginable. They had working horses, buggy horses, riding horses and race horses. They sold some of their horses to the cavalry as re-mounts. They kept the work horses and the riding horses in separate areas of the Swell." (Courtesy Monte Swasey.)

Kenneth Wareham is on one of the desert horses. Ray Wareham said some of these desert horses had a hard time staying in town. Any time they got loose, they would head for home in the Swell, and it would be a long ride to go get them. This one particularly liked the desert. (Courtesy Ray Wareham.)

Swasey's Cabin still stands beneath the monolith called Broken Cross. A Swasey story tells of Sid and Charley returning to one of their cabins and finding a bear inside. Sid surprised Charley by shoving him inside and closing the door and calling, "Now Charley, you fight that bear fair!" No one is sure how fair the fight was, but Charley had a new bear rug. This cabin, built in 1921, is a historic site visitors in the area can see. (Courtesy Ben Grimes.)

Children of Royal and Eva, grandchildren of Joe Swasey, standing from left to right in stair-step formation are Elaine, Royal Jr., Dudley, Glenn, and Monte. (Courtesy Dixie Swasey.)

Thaddeus Hambrick was an early settler on the Swell. The property he acquired through the Desert Land Act is still called Hambrick Bottoms. He and his family lived there for many years. Their baby girl Lily died at the farm, on the south side of the San Rafael River during high water, and they could not get across the river to bury her in a town cemetery. Lily's grave still stands on the hill overlooking the river. (Courtesy Jim Kennick.)

The Star Mail Route followed the Spanish Trail from Salina, Utah, to Ouray, Colorado, and a post office was set up by Sylvester Wilson, who operated the route. It was the first post office in Castle Valley, and as others moved into the area, it became the town of Wilsonville. Later, according to Jim Kennick, his grandfather Thaddeus Hambrick bought Wilsonville from Wilson, who sold out and moved to Wyoming, becoming the first settler of Jackson Hole. (Courtesy Carolyn Jorgensen.)

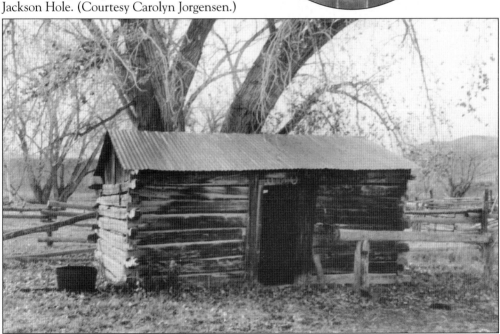

In later years, Royal and Eva Swasey had a little museum, which housed their collection of antiques. They wanted to preserve pieces of the pioneer way of life. Royal also had some of his handmade furniture and many novelty items that he created. School classes visited the museum as a field trip where Royal would teach the kids about the way of life in Emery County in an earlier period. (Above, courtesy Utah State Historical Society; left, courtesy Swasey family.)

About the same time as the Swasey cowboys were calling the Swell "home," bandits were calling it a hideout. Although the Swaseys were never part of the Robber's Roost Gang, family stories say they knew most of the outlaws and provided fresh horses to them from time to time. Matt Warner, pictured right, was an outlaw who became legendary. He was born Eurastus Christensen. He joined up with Butch Cassidy in his outlaw career and later said, "Butch and me liked to give lots of our money to the poor, the needy, and the deserving. In this way we made sort of Robin Hoods of ourselves in our own eyes, gained a lot of popularity and protection from the public, and squared ourselves in our own estimation. . . . We overheard a storekeeper refuse credit to a starving farmer and his wife that had walked fifteen miles [to the store]. We bought these deserving nesters a good wagon, team, and a set of harness, filled their wagon with enough provisions to last them all winter, and started them back home so happy they was both crying and trying to kiss our hands. The crowd cheered and was so happy I believe they was glad we took all their money from them that day before at the [horse] race." (Courtesy Dr. Steve Lacy, Footprints of the Past Museum.)

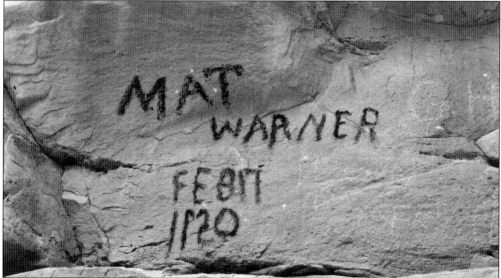

Matt's signature is found on a rock in the Buckhorn area of the Swell. He spelled his alias with two Ts, but perhaps he was in a hurry at this time because the date is difficult to read also; the "9" is backwards and narrow, but it reads "FEB 17 1920." When Warner returned to Price, having turned his life around, he became a respectable man. Everyone knew him, and by all accounts, he seemed to be well liked. He once ran for sheriff with his real name, Erastus Christensen, but lost the election. No one knew who he was, and it was speculated that if he had run as Matt Warner, he would have won. (Courtesy Ben Grimes.)

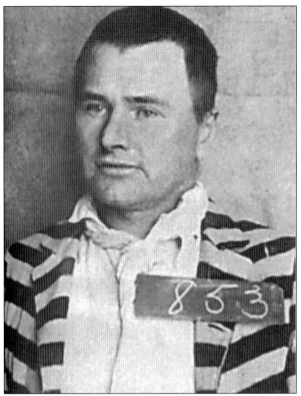

Warner ran away from home at age 14, erroneously believing he had killed another boy in a fight. He changed his name and began to run with the outlaws who hung around the San Rafael and Robbers Roost country, including Tom McCarty and Butch Cassidy. Matt Warner was arrested and served a term in the Sugar House Prison in Salt Lake City. He was sentenced for five years and served three when he was given parole for good behavior. He changed his life, moved to Price, Utah, where he became a deputy sheriff and justice of the peace, and spent the rest of his life on the side of law enforcement. In his short history, Charles Gorley, who lived in a dugout along the Price River, said, "They would always get the toughest gun man, for a cop at Price as they could find as he had to be real men and tough to compete with the outlaws that was around Price." Warner wrote a book about his outlaw days: *Last of the Bandit Riders*. He told how he and his fellow bandits had erected a sign marked "Poison" at the spring, shown at bottom left. When revisiting the site with a friend, he exclaimed, "God, what memories!" He went on to explain that when the officers saw the sign, they turned back from their pursuit of the outlaws for this was the only water in an extensive region. (Both courtesy Dr. Steve Lacey, Footprints of the Past Museum.)

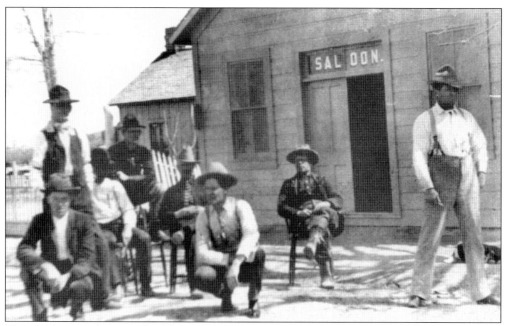

This rarely-seen photograph of the Robbers Roost Gang belonged to Matt Warner. He identified each member and published it in *Last of the Bandit Riders*. From left to right are Arthur Parker (Kid Parker), Harry Longbaugh (Sundance Kid), Robert LeRoy Parker (Butch Cassidy), Dan Parker (Kid Ricketts), Dan Gillis, Elza Lay, Deputy Sheriff Tom Farrer, and Matt Warner. All gathered in front of a saloon in Green River, Utah, which is still standing. (Copyright 1938, 1980 Dr. Steve Lacy, Footprints of the Past Museum.)

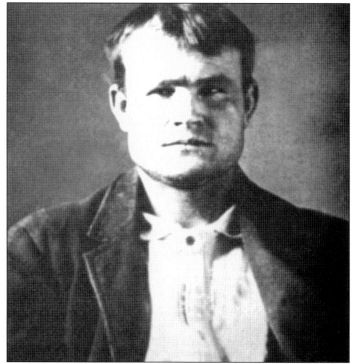

Butch Cassidy had many friends in Castle Valley; stories abound of Butch and friends staying in local hotels, eating and drinking at local saloons, and paying generously for everything they bought. Ray Wareham of Ferron says, "Granddad run cows out in the Robber's Roost when the Wild Bunch were out there. They were friendly to him—those guys. Once in a while, he'd come up missing a cow, and he'd just look around and find the hide, and there'd be about three times the value of that cow, in money rolled up in that hide." (Courtesy Utah State Historical Society.)

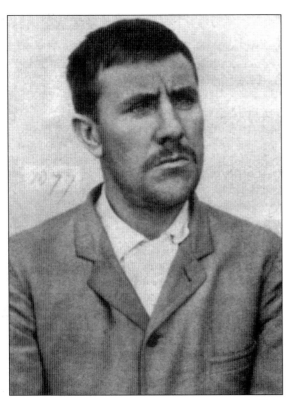

Azariah Tuttle (below) was sheriff of Emery County from 1884 to 1902. He organized a posse, consisting of four men, to track Joe Walker (left), who had been rustling horses from Emery County residents. They caught up with him in Mexican Bend, where Joe shot Tuttle in the hip. The posse headed to Price, leaving him lying on the ground. Many accounts say Walker saw the posse leave and offered him water and other assistance before making his getaway. Tuttle laid there for two cold March nights before help arrived in the form of a 50-man posse. One of the rescuers said, "Tuttle would let out a yell in pain every time the wagon wheel hit a rock or rut in the road, and it wasn't a very good road." He walked with a limp the rest of his life. One year later, Joe Walker was gunned down. Some accounts say it was for cattle rustling, and others say he was in on the payroll robbery. Discussion about which is right continues to the present day. (Both courtesy Dennis Tuttle.)

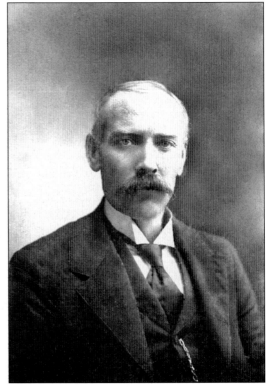

The Pleasant Valley Coal Company store and office (below) was in Castle Gate, Utah. The largest robbery by Butch Cassidy and his bunch in Castle Valley was the 1897 theft of the payroll from this company in Castle Gate. The story goes that Butch and his associate Elza Lay (right) idly hung around town for some time before the payroll train arrived. Then they followed the paymaster up the stairs to the second-floor office and seized bags of gold and silver coins. They escaped with some $8,000 in gold. Relying on fresh mounts stationed by confederates at strategic intervals, they fled across the San Rafael Swell to their refuge at Robbers Roost. Charlie Gorley's account says his brother James was with Cassidy, and they threw him the bag of silver. He was riding bareback and had to ride so hard and fast, he dropped the bag of silver. According to Gorley, the posse went after Joe Walker, "but he never stole anything but horses and cows." Most stories say that he almost always stole from the relatives of the people who took his family's farm, including his own inheritance. (Both courtesy Ray Wareham.)

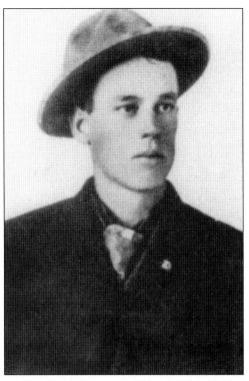

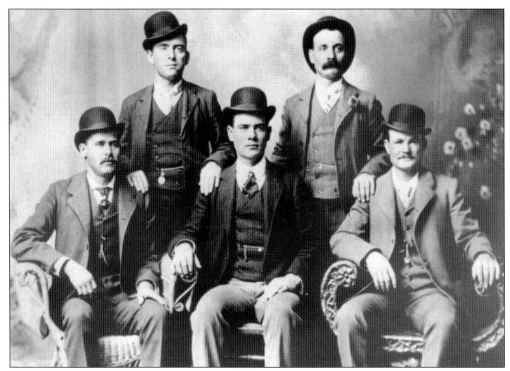

According to some historians, this 1900 photograph proved the undoing of the Robbers Roost Gang because they had gotten too cocky for their own good. Up to this time, most law enforcement did not know what they looked like. Once the photograph was taken in Colorado, it was copied and sent out to towns throughout their playgrounds. (Courtesy Utah State Historical Society.)

Pearl Biddlecome Baker grew up on Robbers Roost Ranch and the tales of the outlaws. She began writing them down while still very young and spent many years researching and verifying facts. Using all of her research and oral history, she wrote a book called *The Robbers Roost Gang* as well as many other books about the area around Green River and the San Rafael Swell. (Courtesy Utah State Historical Society.)

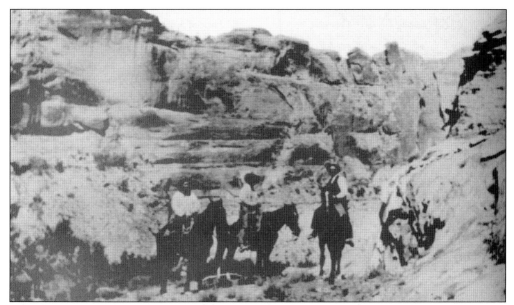

In his biography, *Last of the Bandit Riders*, Matt Warner described their legendary hideout: "A natural fortress in the Robbers Roost Region, where on several occasions, bandits held back twice their number of officers. This is a canyon that no one can enter from below because of the high, straight-walled precipice reaching across the canyon. Entrance is only from a single difficult trail above this point. The horseman on the left is Matt Warner." (Courtesy Dr. Steve Lacey, Footprints of the Past Museum.)

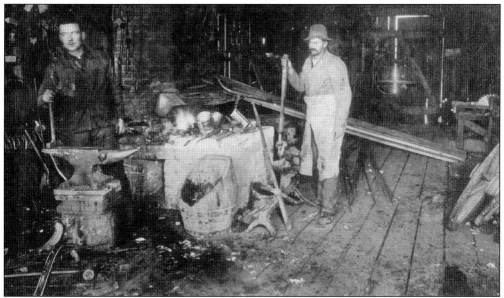

Joe Swasey (left) and Chris Halverson (right) are pictured in the Swasey Blacksmith Shop in Green River. Later in his life, Halverson was asked about the Robbers Roost Gang. He said, "The Roosters was the finest people you ever saw. They wouldn't harm a hair on your head, if you didn't have anything. 'Course, if you was carrying around a lot of money or if you was trottin' about on a fancy saddle horse, they might take it away from you. But any man with money or a fine horse had no business in this country anyway." (Courtesy Green River Archives.)

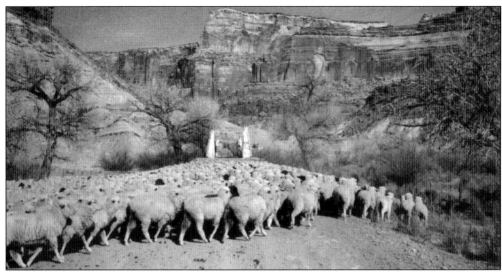

The Swasey wranglers and the robbing "Roosters" shared the Swell with many ranchers who had grazing permits for their cattle and sheep. Several families had large herds of sheep, like the above belonging to the Jorgensens, whose family has run sheep on the San Rafael since 1920. There were extensive herds of sheep in the area, and many Emery County men earned money by working in shearing sheds for several weeks in the spring; others found full-time work as sheepherders. Below, Samuel James Rowley (first row, left) and his brother Walter (first row, center) are working with others in a shearing shed located in Miller Creek around 1905. Sheep are very passive animals, and if they are held under the neck, they will remain still for quite some time for shearing. (Grazing permits for sheep on the San Rafael are no longer allowed, in order to protect the largest herd of desert bighorn sheep in Utah.) (Above, courtesy Carolyn Jorgensen; below, courtesy Vernell Rowley.)

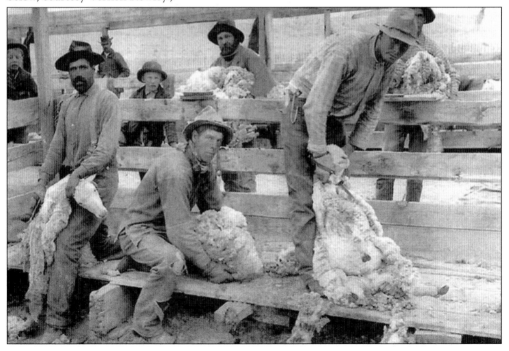

Byron Johansen, known to everyone as "By Jo," ran a large herd of cattle and horses on the San Rafael. He is on his horse Crane with Henry Seeley in the background. By Jo raised Hereford cattle along with the rest of Emery County until 1957, when he was talked into trying Brahma cattle, realizing they were more adaptable to this harsh country. He imported some Brahmas and started raising them successfully. (Courtesy Ina Lee Magnuson.)

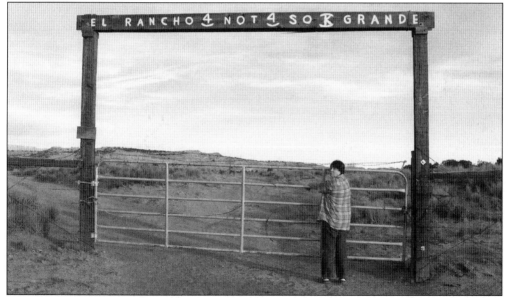

Betty Smith has a delightful sense of humor. When she and her husband, Wayne, first started this ranch on the San Rafael Swell, she chose the name El Rancho Not So Grande. Betty allows people to wander around the property where her family used to live. There is a sign in the rock house that says, "We live by the code of the West: If it's not yours, don't take it; if it's not right, don't do it; if it's not true, don't say it." (Courtesy Ben Grimes.)

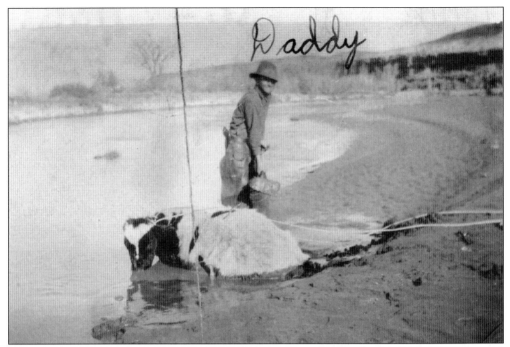

Morris Singleton is working to get a cow out of the quicksand along the San Rafael River around 1915. The nature of quicksand is the more something struggles, the deeper it goes. (Courtesy Sam Singleton.)

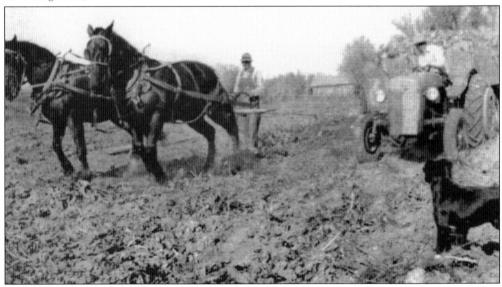

After World War II ended, the nation began a wild ride of progress and change that affected all fields of life, including farming and ranching. James Oveson of Elmo is seen with a horse-drawn plow challenging his son on a tractor. Some Emery County farmers had tractors in the 1930s, but for others, it was difficult to give up the old ways. Farmers who remember plowing with a horse say the tractor was the most important farm technology. It changed the nature of farm work: farmers could plow one acre a day with a team of horses; 10 acres a day could be plowed with a tractor. (Courtesy Joe Oveson.)

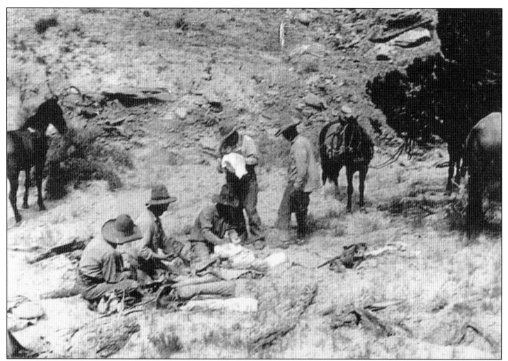

Here is an early photograph of the Swasey cowboys making camp for the night on the desert. Note the bedroll and other preparations for camp. Cowboys still ride through the Swell herding their cattle, but less grazing land is available than in the early days. (Courtesy Swasey family.)

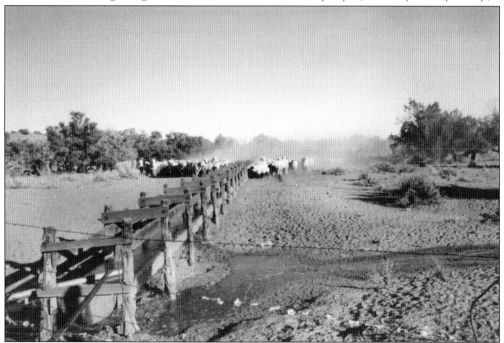

One of the oil companies drilling for oil found water instead. A well was developed, and a large trough for the animals was built around the 1930s on the Swell. (Courtesy Carolyn Jorgensen.)

A cowboy's best friend is his horse, and Hagar (above) was the best of all. She helped Ray Jorgensen tend his sheep for 25 years. (Courtesy Carolyn Jorgensen.)

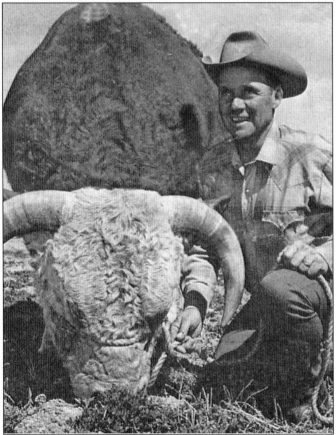

Ray Wareham is posing with his champion Hereford bull. Herefords were the breed that the Cattlemen's Association of Castle Valley chose to raise. Permits for most grazing areas specified that only Herefords, B+ grade or better, could use these grazing lands. Ray later introduced Black Angus to the area. (Courtesy Ray Wareham.)

Five

SETTLEMENTS SURROUNDING THE SWELL

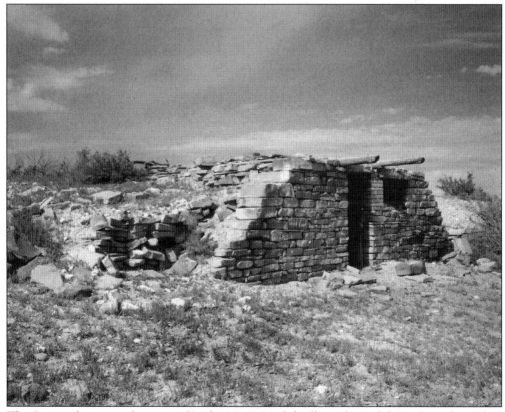

The Swasey dugout in the town of Molen is a typical dwelling place of the early settlers. They were built as temporary shelters until settlers could get enough timber from the mountains to build a cabin. Dugouts were holes dug into the hills, supported by timbers inside with a rock or log face and a doorway. Some people just used quilts as a door. (Courtesy Swasey family.)

The inside of an old dugout can be seen in the upper photograph, showing that dugouts often had more than one room. They were miserable places to live, according to many accounts. Often in the spring, snakes and other "critters" would drop out of the ceiling. As soon as possible, the settlers built log cabins, which were much more comfortable than dugouts bit still had dirt floors. Dirt floors were cared for by sprinkling water on them and then sweeping them. This was done until the surface was hard and "clean." Chinking between the logs had to be replaced yearly because it would crumble and break away, as seen in the below photograph with Royal Swasey enjoying his moonshine. The Swaseys had a still near their ZCMI mine on the Swell. It was recently found by a local resident and returned to the Swasey family. (Left, courtesy Mar Grange; below, courtesy Swasey family.)

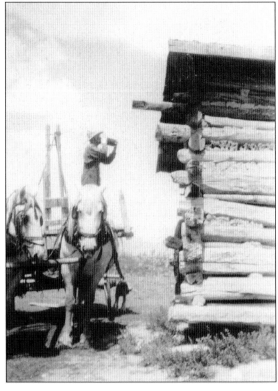

Orange Seely was called by Mormon church leaders to take a group of settlers from San Pete County over the mountain to Castle Valley. It was the second time he had pioneered a settlement. His family left a well-established community on the green valleys of San Pete to come to the desert. His wife, Hannah, who had never sworn before, took one look at the new area and said, "Damn the man who would bring a woman to such a God-forsaken place." Seely was appointed bishop of the whole county area. Historian Kent Powell says, "Local tradition describes Bishop Seely as a man of immense girth who made his pastoral rounds riding one mule and leading another laden with staple food items to be distributed to needy families, blacksmith tools for the shoeing of horses and sharpening of plowshares, and dental forceps to remove aching teeth." Orange Seely is pictured here with a pioneering medal and Utah Indian War veteran medals. (Courtesy Emery County Pioneer Museum.)

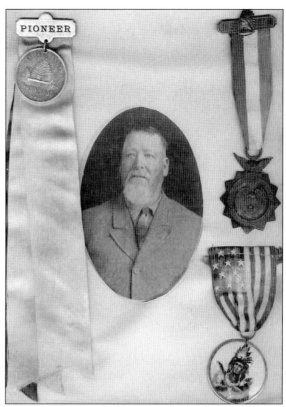

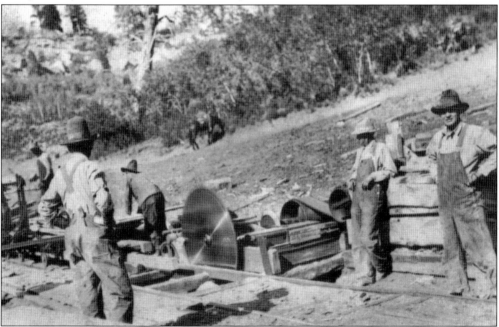

Sawmills were important to the growth of a community. Construction of schools and churches began almost as soon as the town locations were chosen. Many sawmills began operating in the forested mountains west of the Swell. (Courtesy Russell Jensen.)

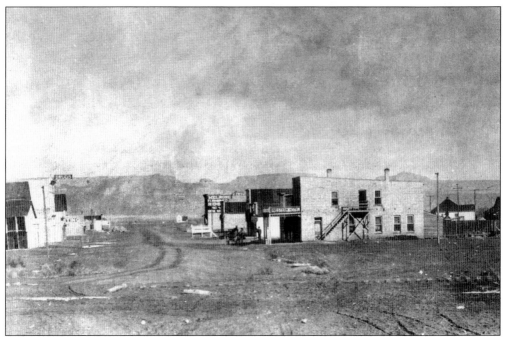

Towns with shops and other businesses began to crop up. Pearl Baker wrote, "While the railroad was going through, Green River was one of the wildest boom towns. There were killings, and fights, drunken bouts, women of more comeliness than character, and all the while the Robbers Roosters plied their trade. A man by the name of Jack Cook came here to start a boneyard (buffalo bones were gathered by the wagon load off the prairies and sold in the early days) but he was killed . . . in a saloon." (Courtesy Green River Archives.)

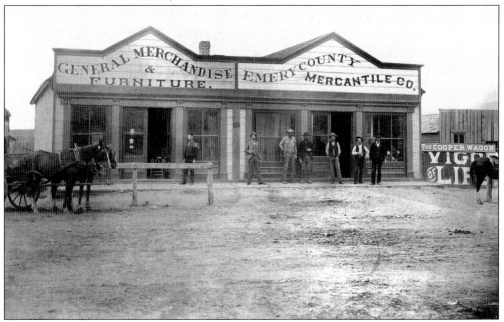

Price was a much milder atmosphere. Emery County Mercantile was located in Price, which is now in Carbon County. In the late 1800s, Price was part of Emery County. (Courtesy Edward Geary.)

Huntington Co-Op and the inside of a store in the early settlement period are pictured here. Most towns had cooperative stores. Money was scarce and most commerce was done by trade. One could trade eggs or grain at the store for the things they needed. Many personal histories talk about children having one egg to spend at the store. (Courtesy Edward Geary.)

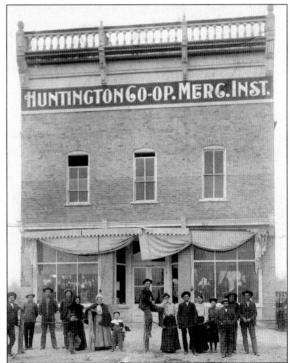

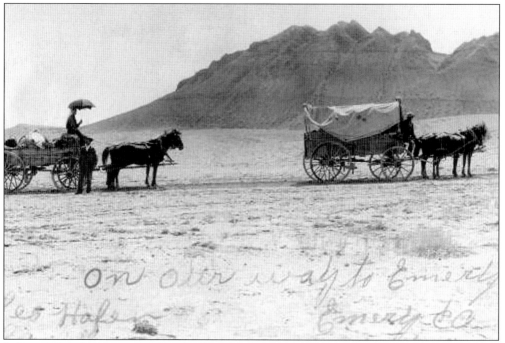

In Lucy H. Nielson's *History of Molen* (a town in Emery County), she says, "A trip by team and wagon from Molen or Ferron to Price took three days. She remembers, "The horses pulling a loaded wagon, walked all the way. Feed, hay and grain were part of the load. The night campgrounds were the valley stream beds." The length of the journey would depend on the weather, road conditions, and the weight being pulled by the horses. During spring and mild winter days, travelers tried to leave early in the morning while the ground was still frozen. Some accounts talk about scraping the wheels every two rotations when it was muddy. (Courtesy Brigham Young University, Special Collections; George Edward Anderson photograph.)

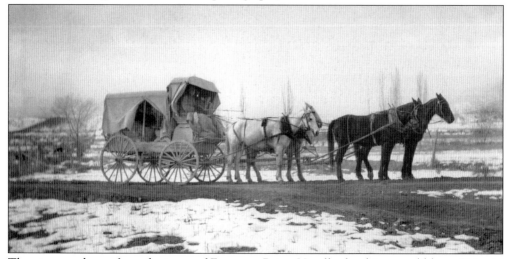

The stagecoach ran from the town of Emery to Price. Usually the driver could leave Price in the morning and arrive in Emery in the evening if the road conditions were good and make the return trip the next day. The stagecoach or mail coach traveled much faster with a team of four horses than a horse and wagon. (Courtesy USGS.)

The most important businesses to get started in a new settlement were sawmills and blacksmith shops. Blacksmiths not only shod the horses; they made everything metal, such as wagon parts and cookpot stands or hangers, and the blacksmith was also the repairman of all things metal. Jesse Christopher Larsen is shown here in his blacksmith shop in Ferron about 1925. (Courtesy Swasey family.)

George Edward Anderson took this photograph of the Otteson children on their farm in Huntington. Anderson was a traveling photographer who liked to capture people in their surroundings, such as this scene that depicts life on a farm as serene and pastoral. He often took pictures of people in front of their houses or on their porches, leaving a pictorial history for each town in Utah. (Courtesy Brigham Young University, L. Tom Perry Special Collections Library; George Edward Anderson photograph.)

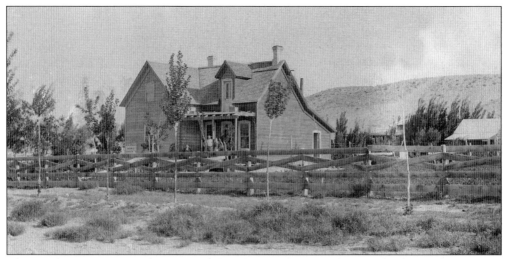

Above is the James Peterson home in Castle Dale. One can see industry and determination to tame the wild desert in the amount of young fruit trees planted and the sophisticated fencing of the front yard. James and his wife, Annie, first lived in a dugout and then built an adobe brick house, seen at far right. Later they built the larger home, and the adobe was used as a washhouse. Adobe bricks were made from mud-clay with fibrous material such as straw and dried in the sun. (Courtesy Brigham Young University, Special Collections; George Edward Anderson photograph.)

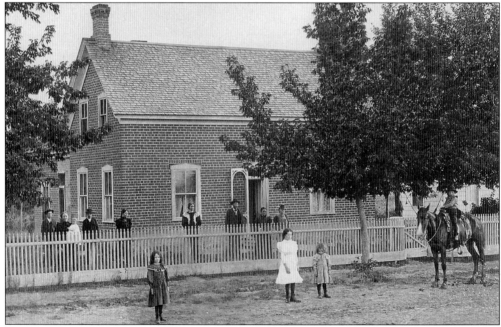

In 1877, Justus Wellington Seeley came to the area with his brother Orange. He built a dugout and then brought his wife, Anna, and three little boys over the mountain to their new home. Anna gave birth to a baby girl on the way into Castle Valley. A marker has been erected at baby Clarissa's birthplace. Their dugout was also replaced by an adobe/lumber house, and then this brick home was built. This photograph by G. E. Anderson shows the whole family in the front yard of the beautiful home. It is now on the National Register of Historic Places in Castle Dale. (Courtesy Brigham Young University, Special Collections; George Edward Anderson photograph.)

The first requirement in settlements was an irrigation system, so canals were built, often before the town. This canal is being dug in Green River. The canal systems were difficult in Emery County; small dams and ditches were built so the water would go where they wanted it to, but many flash floods in the area would destroy their hard work. But they would persevere and build and dig again. (Courtesy Green River Archives.)

The effects of a flash flood are shown in the photograph in Helper where residents are trying to clean up. Flash floods still occur in this area, but reservoirs and better established canal systems keep them from doing the amount of damage they once did. (Courtesy Brigham Young University, L. Tom Perry Special Collections; George Edward Anderson photograph.)

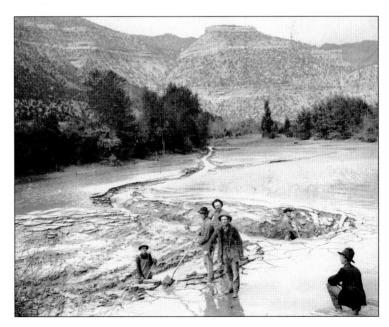

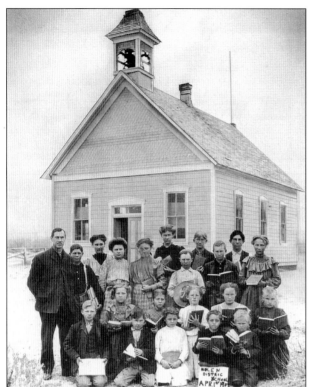

This is the Molen school with the children and teachers. Because of the difficulty and length of time it took to travel in those early years, every town had its own school, no matter how small the town was, and it was usually the first community building to be raised in a settlement in Utah. Today one high school serves the whole county. (Courtesy Emery County Historical Society.)

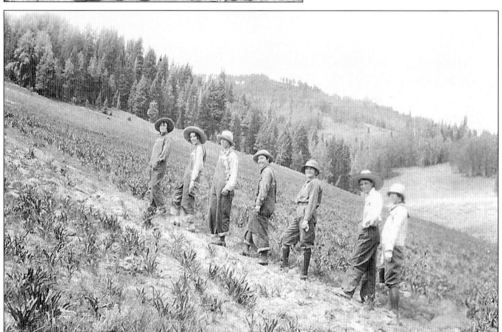

The girls from Huntington High School's 1924 junior class are photographed on a class hike as their spring outing. They are on the mountain in Huntington Canyon hiking up to Cleveland Reservoir, which is near the summit of the mountain. It is interesting to see the girls in pants in that day. That made the adventure all the more exciting. (Courtesy Diana Potter Ware.)

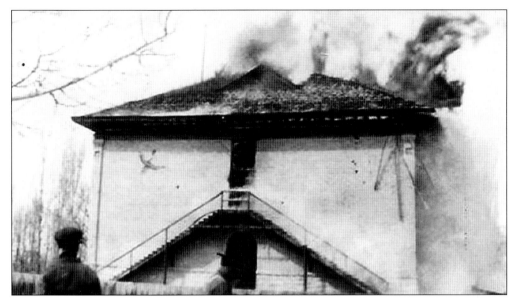

Fires were fairly common in the early years. A burning building was a community event where everyone would gather to watch or help. Historian Edward Geary noted that fires usually happened in the winter from the stoves burning high and long to heat the house or in the late summer/ autumn during canning season when the fires were kept hot for extended periods of time. The burning school above was located in Huntington. According to Addie Richards, who was a student then, the teachers had asked the school board to build steps from the upper floor as a fire escape, but nothing was done about it. The teachers raised money and had the steps built shortly before the fire started, and as a result, all of the children escaped the school building safely. (Courtesy Mildred Johnson.)

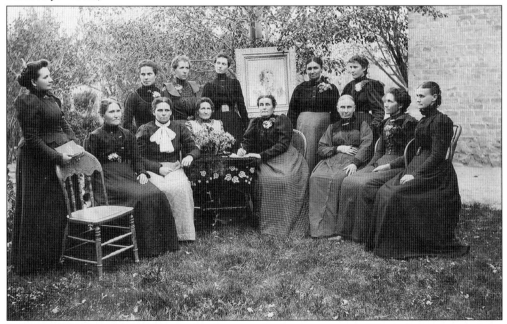

Ladies in Huntington are meeting for their regular literary society. The ladies in most of the towns had societies that heightened their level of culture and refinement.

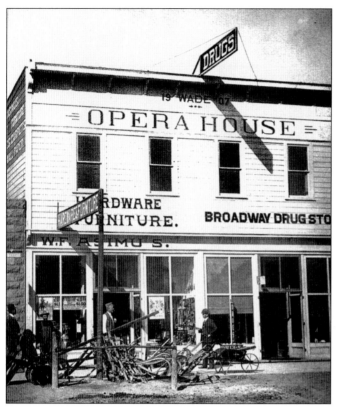

Green River store has many plows in supply, suggesting the photograph was taken in the spring. Notice the Green River Opera House above the stores. All communities had some sort of playhouse or community building where plays could be produced. Theater was encouraged in Utah as a diversion from the hard and tedious life in the desert. (Courtesy Green River Archives.)

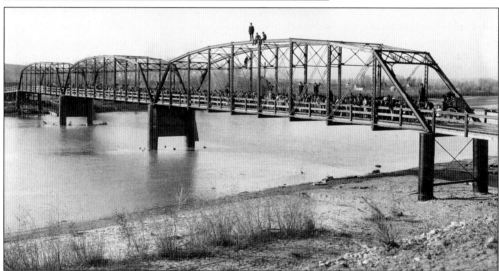

The railroad was built through the town of Green River, and when the trestle bridge across the river was completed to meet the tracks on the other side, there was a major celebration. The town grew as the bridge was being constructed. Workers built dugouts and homes, and others came for the opportunity to start businesses in a railroad town. For the dedication ceremony of the bridge, people came from far and wide, even riding the train to the new railroad stop. Food was served in large quantities for the event. Attendees completely covered the entire bridge for this photograph. (Courtesy Utah State Historical Society.)

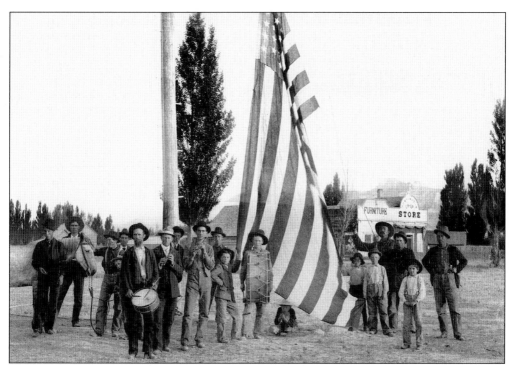

In the 1890s, the Fourth of July was a major event and everybody went to the celebration. A large American flag swung from the rooftops of the meeting houses. Descriptions tell of decorating the inside where programs were held with strips of red, white, and blue cloth. The day started with everyone from the town present saying the Pledge of Allegiance and singing "The Star-Spangled Banner." There were songs and recitations, games, races, dances, ice cream, cookies, and all sorts of baked goods. Celebrating continued through the evening and always ended with dancing. (Courtesy Brigham Young University, L. Tom Perry Special Collection; George E. Anderson photograph.)

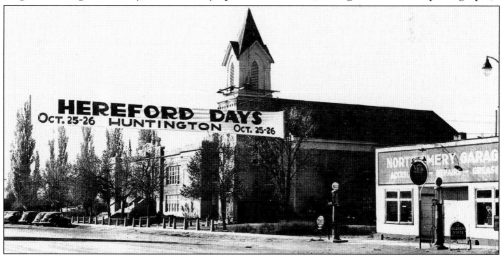

When the cattlemen's association decided to collectively raise Herefords, Huntington encouraged it with a Hereford Days celebration. It was used as a way to promote better breeding stock. Future Farmers of America held a stock show encouraging the younger generation with these same goals. (Courtesy Edward Geary.)

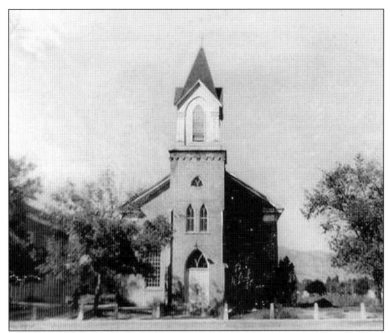

Huntington Tabernacle was built on Main Street. It was a meeting house for the Church of Jesus Christ of Latter-day Saints (LDS), or Mormons. It had thick walls, so the windows when open acted as shelves. Women would bring their food to a church gathering and place it in the windows, which was not always a good idea if there were teenage boys outside. (Courtesy Addie Richards.)

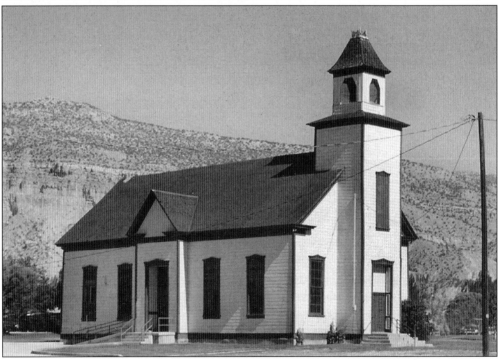

The old church in the town of Emery is still standing. It is the only town with its original church. All towns in Emery County, with the exception of Green River, were built as Mormon communities. People were called by Mormon leader Brigham Young to establish towns in several Western states. Each community had a Latter-day Saints church building, and other religions also built churches in the towns, but one old-timer resident of Green River, Chris Halverson, noted, "We never needed a jail until we got us a church!" (Courtesy Emery Town.)

It is a rare sight to see an elephant and camels walking through Emery County. Above is a circus walking from town to town in 1912. James Potter of Cleveland remembers when he got to go to his first circus, around that time. It was an experience he never got over. He and his siblings learned to walk the tightrope, and they built a trapeze to entertain locally with their high-wire act, Roman bareback riding, and other stunts. Part of a poem by him, "The Circus," describes his feelings: "A one-ring circus stopped in our town; the kind that plays at fairs. Some elephants and lions, a couple of clowns, a snake and a pair of bears. The solo trapeze was a good one And the girls who walked on a wire. From then on, I dreamed and played circus, And I never seemed to tire. I'd make a cage of the kitchen chairs And in it I'd put my cat. Oh, I was the king of the sawdust ring, In Dad's old duffy hat." (Right, courtesy USGS; left, courtesy Dianna Potter Ware.)

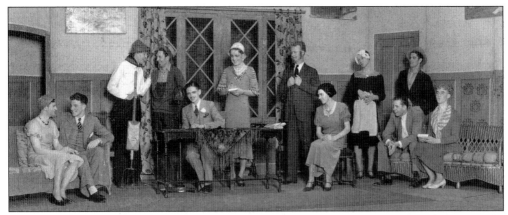

Elmo Geary researched the history of drama in Emery County for his master's thesis in 1953. He found many photographs and memories of the early days of acting and performances. Geary started the drama department at the College of Eastern Utah and the theater there carries his name. He is dressed as a woman (above, seated in a chair fifth from the right) in this 1925 all-male-cast play. Below are a few students in Huntington High School's opera group. A great deal of work went into backdrops, staging, and costuming for the plays, and almost everyone in the community turned out to see them. (Both courtesy Edward Geary.)

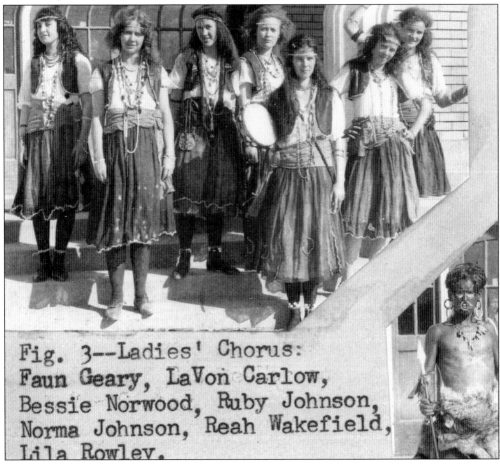

Fig. 3—Ladies' Chorus:
Faun Geary, LaVon Carlow,
Bessie Norwood, Ruby Johnson,
Norma Johnson, Reah Wakefield,
Lila Rowley.

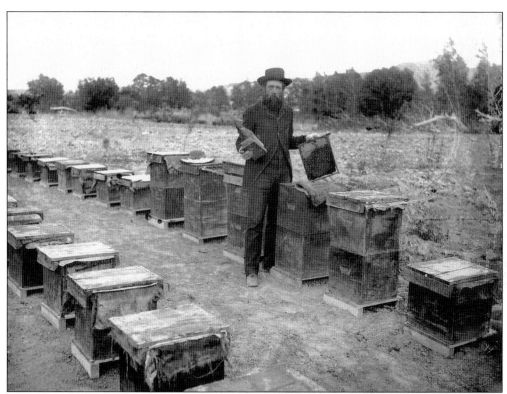

Christian Otteson was one of the many beekeepers in Castle Valley. Lucy H. Nielson recorded that her family also raised bees and that they had 58 swarms. Sometimes they would fill 435 one-gallon cans in a day. She said, "Some hives had three top boxes with seven frames filled and capped on both sides—clear beautiful sweetness no human could make." There were many beekeepers throughout the county, and Emery County honey won prizes at both the Chicago World's Fair in 1893 and the St. Louis World's Fair in 1904. (Courtesy Brigham Young University, L. Tom Perry Special Collections; George E. Anderson photograph.)

This 1927 photograph from Addie Richards's collection shows two people completely covered with gunny sacks over their heads. The words written across the photograph are "Ready for Bees." Most likely they were following a swarm of bees. Lucy H. Nielson wrote, "To find a swarm in the trees or brush was to hurry home for a beehive; usually it was 'finders, keepers!' unless . . . it was near a bee yard. Swarms have been followed several miles before they alighted." (Courtesy Addie Richards.)

Williams - Baker -

This automobile is traveling past the San Rafael Reef. Automobiles made traveling delightful in those days. People with automobiles grouped together and went on tours such as from Price to

Thompson—Reefe—25

Emery and back in one day. The lure of the open road sang out to everyone. (Courtesy Green River Archives.)

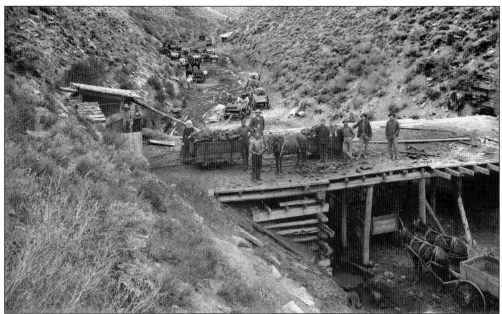

Emery County has a lot of coal in its mountains and a long history of mining. These photographs show two different portals in the same canyon. Above, the portal to this mine in Huntington Canyon is on the left side of the photograph, where the bridge was built to dump coal into beds of wagons as they pulled through underneath. In 1936, Harvey Brinkerhoff started working in coal mines; he was 20 years old. He earned 90¢ a ton for shoveling coal, and he could load nine cars a day. He said, "We walked into the mine and we loaded coal in a two wheeled cart, and they'd wheel it out to the mouth of the mine and dump it down a chute. It was dark, but we had lights on our hats; it didn't bother me. We had a guy come up there and work with us, and every time the roof would crack, he would break and run. The roof wasn't as dangerous as he was: dark and black like that, and break and run! Then he would run into things; run into machinery or run into other miners. I told him once that if I were in his shoes, I would give mining up as an occupation and try something else." (Both courtesy Brigham Young University, Special Collections, George E. Anderson photograph.)

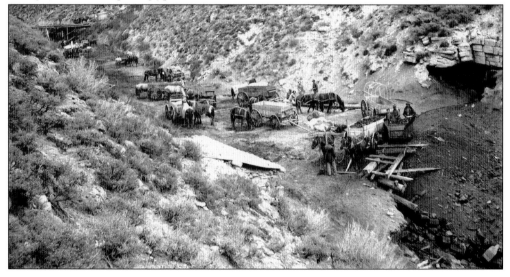

Six

A PECULIAR SCRAP PILE OF MINERALS

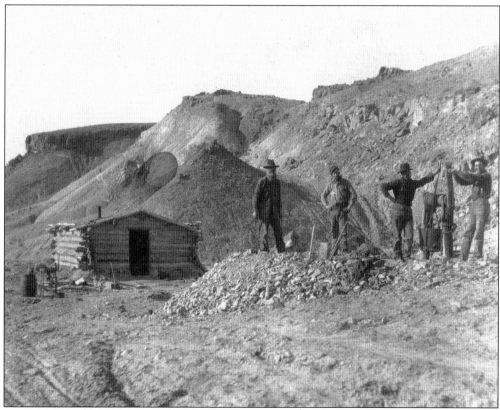

Uranium mining at Temple Mountain began in the late 1800s. A great deal of testing and experimenting with the "wonder" element was going on, and the market was good. Madame Curie seems to have been a household name, and most accounts from that period mention her and that the ore they mined was sent to France. Many accounts say that she actually visited Temple Mountain to see where ore of that quality was coming from. This has not been substantiated, but it is still part of the folk history of the area. At the time, it was vanadium that the markets were interested in, and so the uranium ore was cast off in piles. Later when the uranium boom began, those waste piles became very valuable. (Courtesy Green River Archives.)

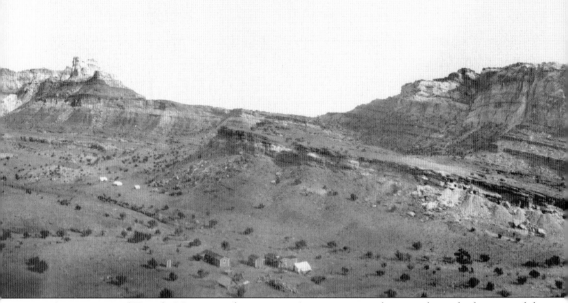

A panorama of Temple Mountain shows miners' temporary settlement along the bottom of the ridge. The large rocky formation on the hill is called the Temple. From some perspectives, it looks very similar to a Church of Jesus Christ of Latter-day Saints temple. Monte Swasey said, "This is where Granddad [Joe Swasey] and old Wyatt Bryan located Temple Mountain back in the 1900s, and started what they called Cowboy Mine. Madame Curie in France was just doing a bunch of experiments with Radium, and she needed this radioactive ore to do her experiments with. It was a high-grade uranium. They couldn't ship anything under two percent." Monte's father, Royal, said that they would begin following a small seam and before long they would have an underground room opened up. These prospectors talked about "finding a big tree." Trees petrified under the right conditions turn into a great source of uranium ore, so they would find a small branch of a tree and begin to follow that to a large-sized deposit. (Courtesy USGS.)

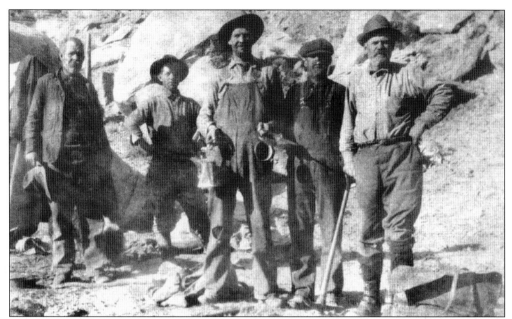

From left to right, Joe and Grant Swasey, Les Wareham, Wyatt Bryan, and Charlie Lynn are mining vanadium in the early 1900s. (Courtesy Swasey family.)

Royal Swasey went out to Temple Mountain in 1916 to mine uranium. He wrote to his wife that he had bagged 150 bags of ore that day. He was tired and sick with a sore throat and aches because of handling all of that uranium. Life was hard in those days; money was scarce, and so the men were willing to take work, no matter how dangerous. Although they couldn't have understood the real dangers of uranium, Royal knew that the radioactive properties could somehow make him sick. In another letter he wrote to Eva, he told her that he had tested his bathwater and it was 1.5 percent uranium. She wrote back and said that she had tested the letter he wrote, the day he bagged the ore, and it had tested at two percent. (Courtesy Swasey family.)

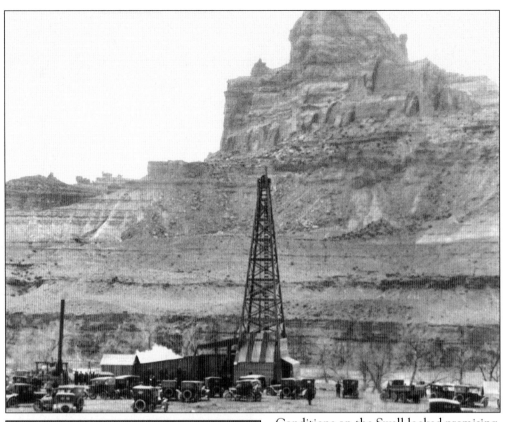

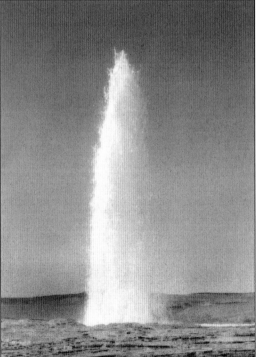

Conditions on the Swell looked promising for oil. Several rigs were set up in different areas to drill for oil. This rig is located at the base of Window Blind Peak. Newspapers of the day ran long articles about how the oil deposits on the San Rafael were most likely to prove to be rich oil beds and it was a good time to invest in oil stock, but not much oil was ever found. (Courtesy Pioneer Museum.)

The Crystal Geyser is a rare cold water geyser that is caused when groundwater picks up certain chemicals to become a mild sulfuric acid and comes in contact with calcium carbonate. The combination causes carbon dioxide to build pressure and force the water through an opening, created in this case by a company drilling for oil near Green River around 1940. The geyser erupts every 12 to 18 hours. It has created mineral deposits of amazing colors and patterns; even the vegetation around the area is coated with minerals. (Courtesy Green River Archives.)

Many kinds of minerals have been found in the Swell besides uranium and vanadium. Gold, silver, ozokerite, alunite, gypsum, manganese, lead, and copper have all been mined, but not in enough quantities to be commercially successful. A cultural inventory of Emery County in 1949 declared the San Rafael Swell as a "peculiar scrap pile of minerals." One of the portals of the Copper Globe Mine is pictured above. Quite a bit of copper was mined here, but it was so costly to get the ore to a smelter that it was not paying off at a good rate. The owners decided to build their own smelting oven, below, and extract the copper on site. A mountain of wood was gathered to keep the oven burning at high enough temperatures, but with the first smelting, the oven collapsed in the high heat before the ore had melted. Today visitors can see three mine entrances, a partially furnished cabin, some of the mine works, and some of the unused wood pile at this historic mine site. (Both courtesy Bruce Funk.)

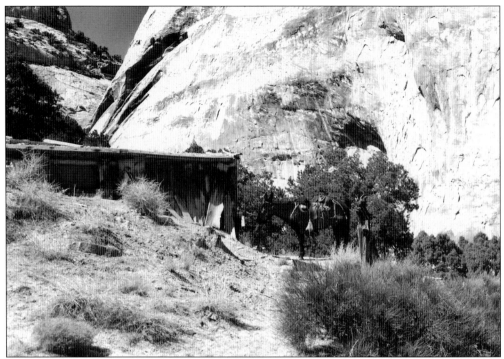

A pack mule stands in front of cabin at the Copper Globe Mine where one can see old relics from its mining heyday. (Courtesy Bruce Funk.)

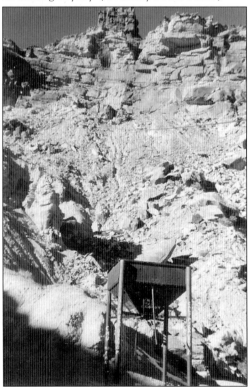

A uranium ore-loading bin can be seen at the bottom of the cliffs. Owen McClenahan wrote a history of the uranium boom in Emery County: "In the year 1949 . . . a large government program was encouraging men to prospect with bonuses paid for by special high grade uranium ore. Men by the thousands flocked into these wastelands in old jalopy automobiles and army surplus jeeps. Here climbing steep slopes until they reached the mineralized sandstones. The worst things that could happen to a prospector would be to find just enough to raise his hopes, his dreams and encourage his irresponsibility to raise money in any devious way he could. Many men lost everything they owned, including their wife and family." (Courtesy USGS.)

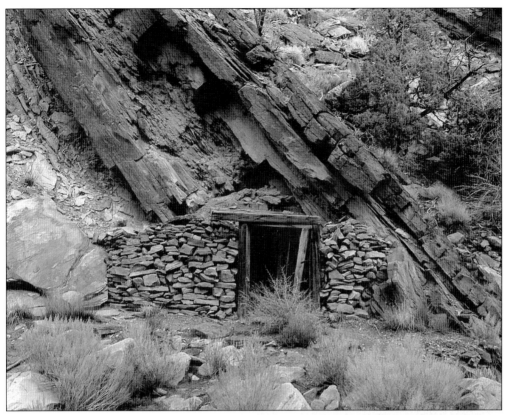

This mine opening is interestingly juxtaposed against the tilted rock layers of the reef. There are 187 adits (or horizontal mine openings) on the Swell. (Courtesy Ben Grimes.)

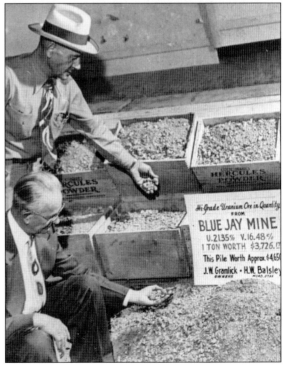

In 1947, Howard Balsley of Moab, Utah, and Fendall A. Sitton of Colorado presented Washington, D.C., with evidence there should be full-scale exploration for uranium on the Colorado Plateau, where the San Rafael Swell is located. The federal government then advertised for prospectors to mine uranium, with a $10,000 bonus if they found high-grade ore. Howard Balsley and his business partner, J. W. Gramick, are pictured here handling high-grade uranium ore from their Blue Jay mine. (Courtesy Goblin Valley State Park.)

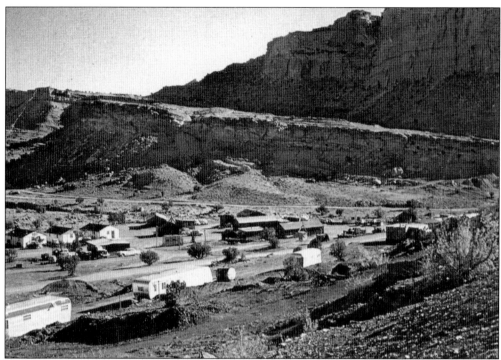

A shantytown sprang up at Temple Mountain during the uranium boom. It was known as Temple City. Barbara Ekker said, "My husband wanted to go out there and mine, so we took his mother's trailer and pulled it out there, and we mined Uranium. Temple City was just trailers and a great big garage where they did all the repairs and stuff like that. You had to haul water. . . . It was rough." (Courtesy Marion Wheeler.)

This was a typical scene in those days near Temple Mountain. The miners brought their families out in their camp trailers for the summer months. There was plenty of space to play and the mining scene was relaxed and open, with few regulations. (Courtesy Marion Wheeler.)

Marion Wheeler mined at Temple Mountain in 1955. In the photograph to the right, he is standing at the Calex Hole, which is the shaft drilled vertically to allow the air movement into the mine as well as to the miners themselves. Wheeler recorded, "The shaft went down 80 feet, and the hole was 36 inches in diameter. The bucket was your ride down into the mine and you just held on. It was the same bucket that the uranium ore was brought back up in and then it was dumped into the truck (seen in the background). It held about 500 lbs of uranium ore. The bucket was let down by a 6-cylinder Dodge engine. The cable had marks on it so the hoist-man knew when to stop to let the men off. Our communications with the hoist-man was by a horn to let him know when to go up or down." Once down to the bottom of the Calex Hole, the mine shafts then were horizontal as they dug the ore out. Below, this couple is sitting on a drill core that came from the Calex Hole. (Both courtesy Marion Wheeler.)

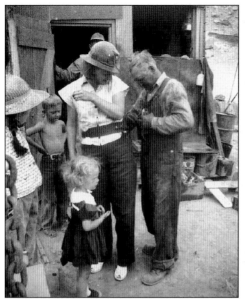

Esther Wheeler appears to be getting ready to go on a tour of the dark, radioactive mine. Barbara Ekker said, "One day I had the bright idea I wanted to go down there. Never again. I've never been so scared in my life going down there because, I mean, you know, if the guy up on top isn't doing his job you're down there forever with no way to get out. These calex holes were more for air and vent. They were mining inside, but they were up on top to let equipment down, and to send the miners down." (Courtesy Marion Wheeler.)

Owen McClenahan said, "I was intrigued with the Geiger counter. L. T. Hunter, a pharmacist in Castle Dale, called me into his office to show me how one rock would sound like an angry rattlesnake, and another rock was silent with only an intermittent click. He told me uranium was found in places where dinosaur bones were found. I was hooked because I knew where tons of dinosaur bones were. This was the beginning of a great friendship. I took tons of rock into his little office a paper bag at a time." They became partners and added L. T.'s brother Albert into the business. (Courtesy Utah Historical Society.)

Old mine works are seen from a distance high on a cliff face. Owen McClenahan said some men came to him with a hot piece of ore but couldn't remember where they got it. They asked him if he would go with them, taking his Geiger counter, and help them find the source. He said, "And find it I did. They were so happy they put my name on the claims. We mined five tons of ore, slid 200 pounds at a time down a rocky slope in a tin bathtub to the place where we loaded it into a truck. Now that doesn't sound like much, but we didn't ever want to try it again. . . . We leased the claims to a company from Washington state. They built a road and a loading bin, but by the second day, they hit the end of the vein. To this day there stands a 75 ton ore bin that had only 15 tons of ore go through its doors." (Both courtesy Mar Grange.)

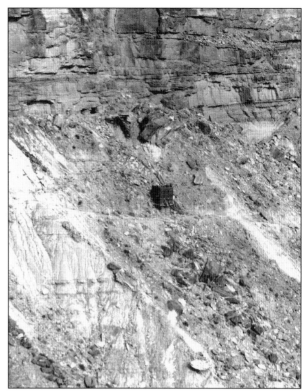

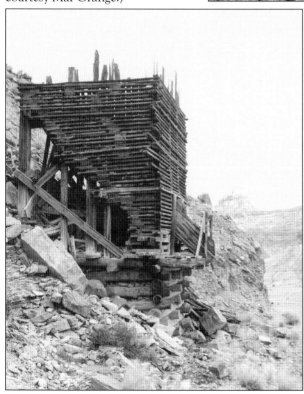

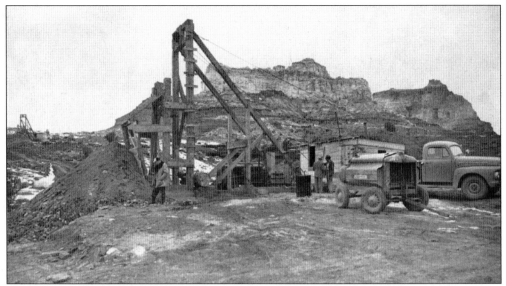

Larger uranium companies came in and either bought or leased the smaller claims. They had more modern equipment and could hire many workers. Consolidated Uranium Mines, Inc. was one such company. Ted Ekker worked for one of these companies and has fond memories. He remembers the uranium boom of the 1950s as a time that will never be repeated in this country. Uranium was needed for national security, so there was a community cause behind the process. There were few government regulations, so he said they had to take care of each other because it's a "bad place down there." The AEC (Atomic Energy Commission) would help workers any way they could, and it was the best time of his life. The people that worked with him were "great, fun-loving, no bickering, and very seldom any troubles happened. It was just a great time to live, I'll tell you. I don't think I have experienced it since, and I don't think we ever will." (Both courtesy Goblin Valley State Park.)

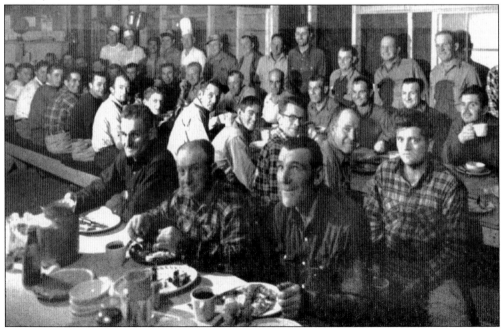

One morning, when Owen McClenahan was prospecting with friends, they turned on their Geiger counters and the counters clicked too fast to count. Owen said, "We immediately came to life and started to check everything in sight. . . . the low spots were the hottest. I checked underneath a rock overhang and found there was no count. Finally it dawned on us that it was fallout from an atomic bomb test at the Nevada testing grounds." When they returned home, the news reported testing had been done a day or two before. (Courtesy USGS.)

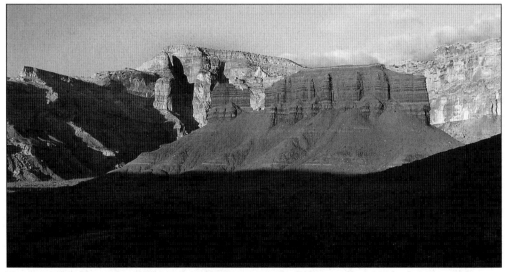

Two men by the name of Tomsich and Hannert staked claims all around what is now known as Tomsich Butte (above). They each staked every other claim as their own. McClenahan said, "They were going it alone each claim—what a hell of a way to do. I felt that partners should trust one another down to the last crying dime." According to McClenahan, John Tomsich later killed himself when his claims failed to produce, but Hannert opened a mine on one of his claims and seemed to make a lot of money for a few years. (Courtesy Ben Grimes.)

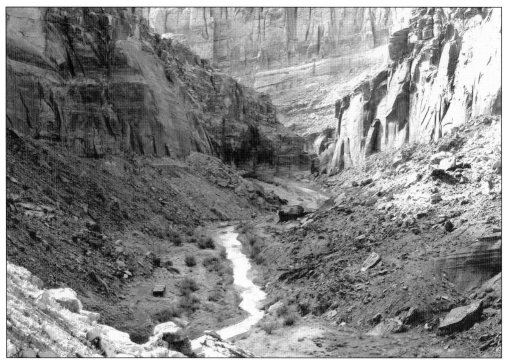

The Hidden Splendor mine is in a remote canyon and was owned and operated by Vernon J. Pick. He made $1 million from the mine and then sold it for $9 or $10 million. Pick gained widespread publicity for a supposedly one-man, heroic exploration and discovery, but serious questions were later raised about the accuracy of his report. (Both courtesy Ben Grimes.)

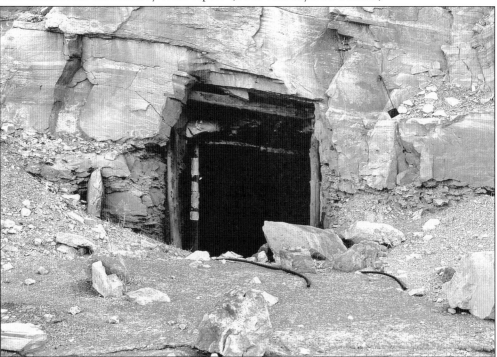

Seven

"EASTERING" AND OTHER SWELL TIMES

Addie Wakefield, 16 years old, poses with her boyfriend, Drew Richards, out on the San Rafael while "Eastering" on the desert in 1925. Addie and Drew were later married and raised their family in Huntington, Utah. Eastering is a term used extensively in Emery County, where the tradition to go out on the desert to celebrate Easter has been happening since the early 1900s. Springtime is the best time to visit the San Rafael Swell. (Courtesy Addie Richards.)

1928

Lucy Nielson said, "Eastering was a time when young folks had many happy picnics." They ate picnic food and played games, hiked around on the rocks and in canyons, rolled Easter eggs, and often fell in love. There is something fun and romantic about the Swell with its unusual beauty. More than just young people went to the desert on Easter. Whole communities went out for either a weekend camping trip or a day of fun. Personal histories tell how in some communities, everyone would meet at the church on Easter Sunday and travel to the Swell together for a church program and picnics. Today thousands of people are found throughout the San Rafael on Easter weekend as the tradition of Eastering continues to grow, bringing people that live far beyond the Castle Valley borders. (Both courtesy Addie Richards.)

Mig & Erda

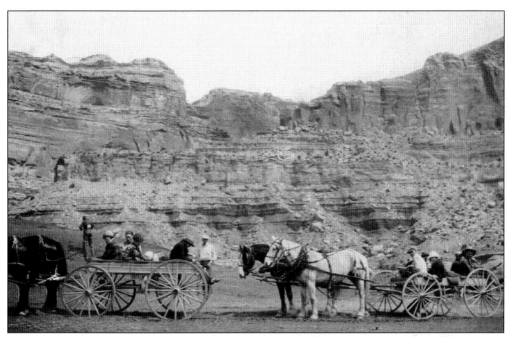

Eastering was always done with family and friends on the Swell. These two wagons are in Buckhorn Draw, which is still a popular place for Eastering. (Courtesy Addie Richards.)

The Swell is a great place for rock climbing and rappelling, and both large and small groups find any number of cliffs to ascend or descend, but it is not a new sport. This photograph, taken in 1926, shows a climber making it to the top of a shale cliff wearing cowboy boots. (Courtesy Edward Geary.)

Schools took students on outings to the desert in the spring. They would often go to Bull Holler on Cedar Mountain, just at the foot of the Red Plateau. These 14-year-old girls are part of a ninth-grade class field trip to the desert in 1923. From left to right, (first row) Vonda ("Bonnie") and Melva Stevens and Sammy Rowley; (second row) Babe Steicklman huddle in one of the many hollowed rocks found in the area with their lunches. (Courtesy Sammy Rowley.)

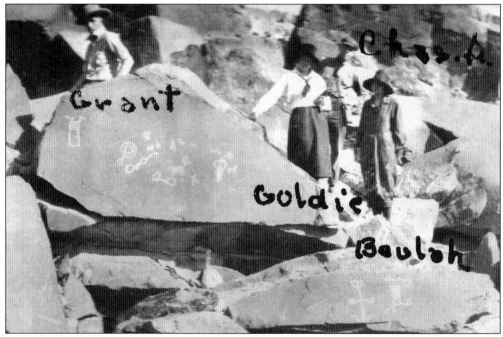

This high school geology class from Green River was on a field trip learning about the geology of the area and the rock art, which they called "hyroglyphics." (Courtesy Green River.)

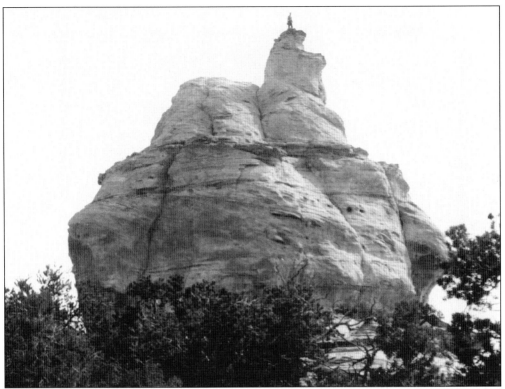

Royal Swasey conquered Tea Pot Rock; he is standing at the very top. Climbing these huge rocks, or "bouldering," has always been great sport on the Swell. (Courtesy Russell Swasey.)

Getting stuck in the mud on the desert was not uncommon with automobiles. Usually drivers had to get someone with a horse to pull them out of the mire. The mud was so sticky and thick that, traveling through it, one would have to clean their wagon wheels off every two rotations. (Courtesy Addie Richards.)

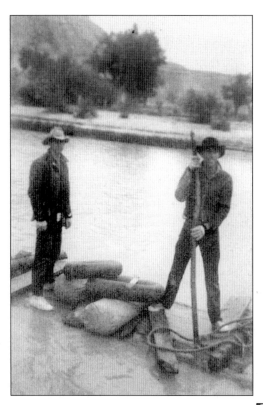

Craig Nielson (left) and his brother James called themselves the "River Rats." This is believed to be the first river trip through the Wedge in 1964. They built this homemade raft from wood held together by barbed wire. They navigated with a long pole and had automobile inner tubes in case of a need for rescue. The photograph shows that their crude raft took on water but it still floated. (Courtesy James Nielson.)

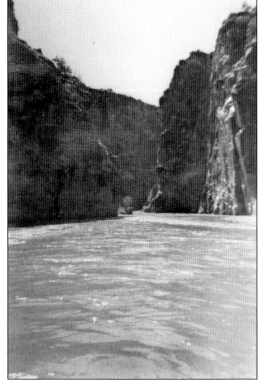

This is the view from the river the Nielson brothers had as they headed into the Black Box. James Nielson is now the supervisor of the mosquito and weed department for the county. In his opinion, the one feature that represents all of Emery County is the San Rafael River. It flows from the west end of the county to the east end. Most of the streams that provide water to the towns flow into it, and it eventually flows into the Colorado River. (Courtesy James Nielson.)

The Nielson brothers love the river. They ran it the following year (1965) and years after that in a canoe they had made out of fiberglass. Above, they are using it to make a shelter. Below are Craig Nielson (right) and Bruce Funk, his brother-in-law. When they started running the river as young men, the river had sharp banks and natural vegetation of cottonwood trees and willows; now the river has been invaded by nonnative tamarisks. It has changed the temperature, the stream flow, and the channel and is destroying the river. James says, "Nature can heal itself if there is a fire or a flood, but it cannot heal itself from foreign plants." Efforts are being made to restore and reclaim this beautiful river. (Both courtesy James Nielson.)

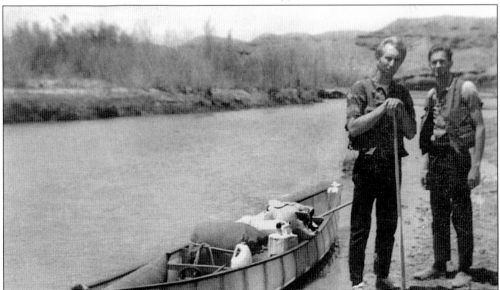

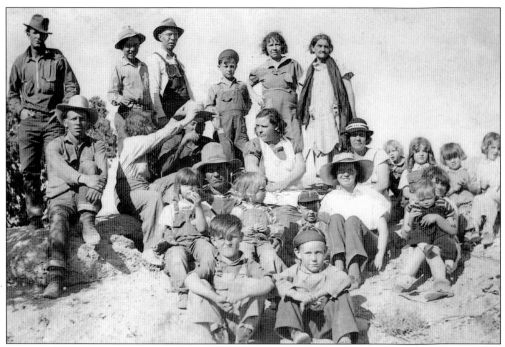

The Swasey family had many gatherings on the desert, including Easter time. Mary Etta, Joe's wife, is pictured here standing at far right with her children and grandchildren. The photograph must have been taken after 1930 because Joe is missing from the picture; he died in 1930 at the age of 69. There are still many Swaseys in Castle Valley, and each of them cherishes the stories and legends of Joe and his brothers. (Courtesy Dixie Swasey.)

Monte Swasey (left) is dressed in his full mountain-man regalia. He makes black powder horns and rifles, as seen hanging above his friend. At the Mountain Man Rendezvous, which still happen yearly on the Swell, the participants spend a few days living as the early settlers of the West lived. They are very authentic in their dress, tanning animal skins and making their clothing; they shoot black powder rifles and homemade arrows; and they make their own arrow points and knives. (Courtesy Monte Swasey.)

Eight

CIVILIAN CONSERVATION CORPS

Pres. Franklin D. Roosevelt created the Civilian Conservation Corps in 1933, when the nation felt hungry and hopeless. There were very few jobs and none for the young men. Idle youth were left to wander the streets of the cities until Roosevelt implemented his plan to put the young men of the nation to work. In 1935, several Civilian Conservation Corps Camps opened up in Emery County. Young men from 18 to 22 years old could join; the average age was 18.5. Every state in the nation had camps of "CCC Boys," as they were usually called. Young men from Emery County joined the local camps. Here two young men are working on the San Rafael Swell. (Courtesy Denver Archives.)

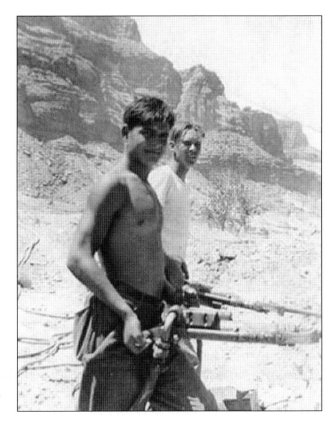

The CCC was organized as a civilian branch of the army at a time in history when the nation was in a great economic depression and the country had been ravished by drought, fire, and erosion. President Roosevelt said, "In creating this Civilian Conservation Corps, we are killing two birds with one stone. We are clearly enhancing the value of our natural resources, and at the same time, we are relieving an appreciable amount of actual distress. And we are conserving not only our natural resources, but also our human resources." Over two million young men joined the CCC in the nine years it functioned. The program saved them and they saved the nation. (Courtesy Denver Archives.)

The CCC Boys were paid $30 a month—$25 was sent home, and the boys could each have $5 to spend. They had beds to sleep on, shelter over their heads, uniforms to wear, plenty of food to eat, and even recreation provided for them. These buildings show base camp in Castle Dale. (Courtesy Denver Archives.)

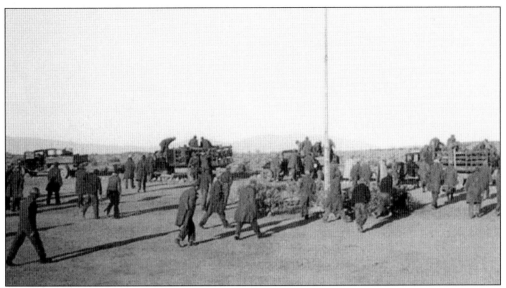

Each day, the young men would leave camp and climb in the back of the truck, their transport to the work site, often singing songs on their way to work. Each camp was assigned to a federal agency. In Castle Valley, they worked for the forest service in the mountains, or the Department of Agriculture-Grazing, where they worked in the desert building roads, fences, cabins, dams, and bridges. (Courtesy Denver Archives.)

The main camps of the Civilian Conservation Corps were in Castle Dale, Ferron, and Green River, but "spike camps" were established near the work project locations in the mountains and desert. This one is located on the Swell. There were some local boys in each camp, and experienced local men served as project supervisors, but most of the CCC boys came from big cities in the Eastern states and had little experience with outdoor work. Owen Price recalled that the farm boys were hard workers who knew how to take orders and get to work. The city boys, he claimed, were slow learners, but they eventually caught on. Working in the San Rafael was an adventure for those whose previous experiences had been confined to urban areas. The boys were sent to areas where manpower was needed. (Courtesy Denver Archives.)

Camp F-11 Company 949 gathered together in their uniforms waiting for a celebration dinner. The first group of young men through the program was issued army surplus uniforms. One former CCC enrollee remembers, "They must have had warehouses full of them [army surplus uniforms], and they preserved it pretty well. It took you about a year to get the mothball smell out of it. And one size fits all." Another former member recalled, "It seems they always gave you a size bigger than you needed. If you complained about it, they'd say, 'Don't worry about it, you're going to grow into it.' Some of the more affluent of us were able to hire a local seamstress to alter it for us for fifty cents." (Courtesy Orlon Mortensen.)

Most of the kids were from similar circumstances, so they made friends easily and had good times and great memories. They had weekends off. Most towns held Friday night dances, and the boys were able to mingle with the girls from Emery County. Many of them married local girls and settled in this area. (Courtesy Orlon Mortensen.)

An unusual sight during the Depression was shelves fully stocked with food. In cities all across America, people stood in bread lines for hours hoping to get a bite to eat or to feed their families. In rural Utah, where they raised their own beef and grew their own gardens, people fared much better, but no home had shelves that looked like this. (Courtesy Denver Archives.)

Each camp had a mess hall. They were fed well. The average recruit gained 12 pounds in the first month. For some, this was the first time having three meals a day, and for most, it was the first time they had dessert every day. They were offered educational classes such as typing, radio, printing, metal craft, leather craft, and social manners. Orlon Mortensen learned photography, took this and other photographs, and developed them in camp. Many of the young men were illiterate. Throughout the nation, 40,000 learned to read while enlisted in the CCC. (Courtesy Orlon Mortensen.)

Every morning, rain, snow, or heat, the boys would jump into the back of the truck that would take them to their specific job. They learned army rules and discipline. Owen Price, a local youth involved in the CCC, called the program, "Roosevelt's Instant Army." He says, "Except for weapons training, they were ready to go to war. They knew Army life and discipline and had learned to work as a team." The CCC boys did a lot of rock and shovel work on the San Rafael Swell. A young man could be promoted to drive a truck, as did Orlon Mortensen, or operate heavy equipment, as did Owen Price. Neither was an easy task in the desert wilderness where there were only primitive or nonexistent roads. (Above, courtesy Orlon Mortensen; below, courtesy Denver Archives.)

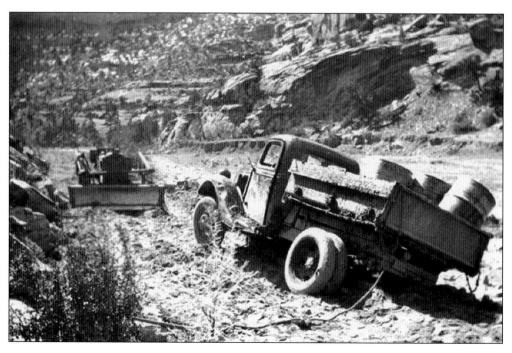

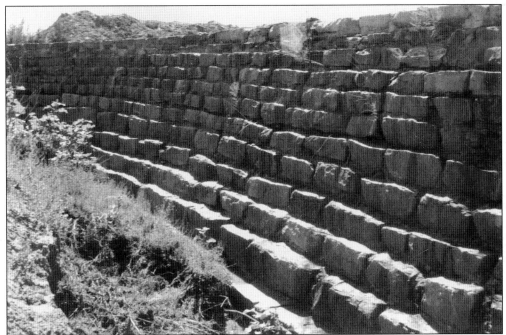

Building rock dams and embankments was done so well that it still gets praise from the public. Monte Swasey said, "It's a regular work of art, looks like a bunch of Masons had done it, instead of a bunch of city boys, come to the country to work." (Courtesy Monte Swasey.)

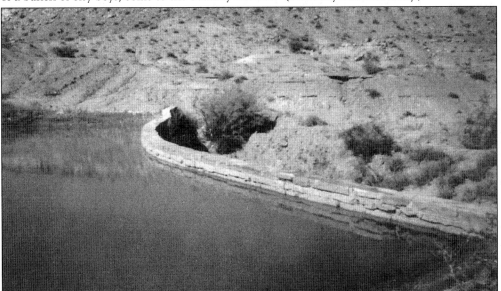

Owen Price remembers, "There was a fellow we called Pop Young. He smoked a pipe. He didn't see very good out of one eye. He had a cane, and he had somebody that would help him with this thing. He'd point out these rocks to these kids; he'd tap it with his cane, and he'd say take that one and put that in this way and that way, 'put in your mortar . . . ' you know? He followed this thing all the way. He had a chair; he was sittin' in his chair, and he'd give his instructions from there to this bunch of kids. He worked those little nooks and crannies into it, there you know, and there's not a crack in it." (Courtesy Monte Swasey.)

The CCC had to build some roads before they could work on projects. The national total miles of roads built by the CCC was 125,000. They built 13,000 miles of foot trails, developed 800 state parks, developed 52,000 acres of campgrounds, stocked lakes and ponds with 972 million fish, restored 3,980 historic structures, planted 203 billion trees, and revegetated 814,000 acres of range land that had been destroyed by erosion and drought! Young men learned skills that they could take with them into adulthood, such as Owen Price, who operated a bulldozer in the CCC and later built roads for a living. The whole nation owes a lot to the hard work of these young men who worked to support their families during the Depression and restored America's beauty after the terrible effects of drought and abuse. (Both courtesy Denver Archives.)

Two members of the CCC were driving down a steep switchback road with sharp turns when their truck hit a rut, bounced off the road, and rolled down the hillside. Both boys were killed. The tragedy was amazingly one of very few that happened; even though they worked on primitive roads, vehicles of the time were not easy to maneuver, and many of the boys had not had a lot of previous training. Owen Price said that his first duty as a new recruit was to fight a fire that had been raging in Huntington Canyon. He said there was not one of the boys hurt fighting that fire, although they did not have any training or safety equipment. He said, "Most of us had brains enough to know to how to stay safe." (Both courtesy Denver Archives.)

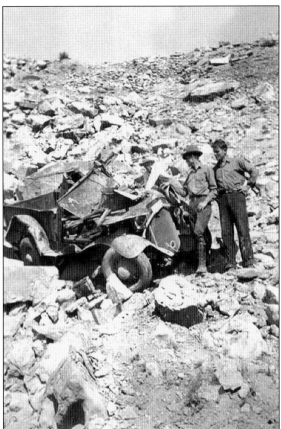

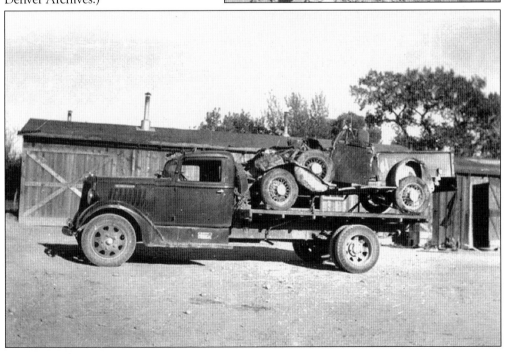

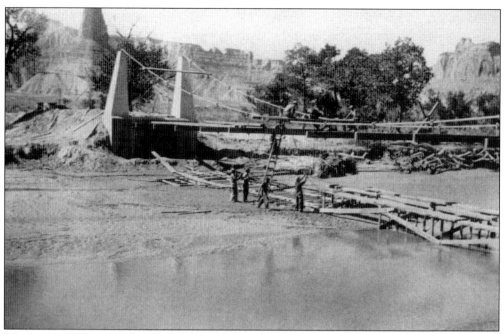

The biggest assignment for Company 959 was to build a suspension bridge over the San Rafael River on the San Rafael Swell. (Courtesy Carolyn Jorgensen.)

Dermis Jensen, a local rancher and trapper, was hired to supervise the young men and help them build the bridge. (Courtesy Russ Jensen.)

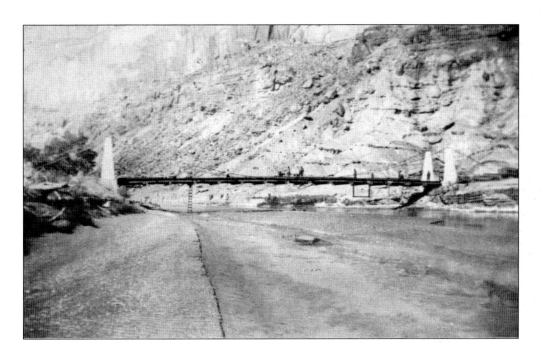

Bridge construction began in 1935 and was completed in 1937. These cables (below) would allow the bridge to move a few feet as automobiles crossed over. Even on foot, one can feel the bridge move as others walk on it, so it is known throughout Castle Valley as the "Swinging Bridge." Since its construction, it has been a favorite gathering place. (Courtesy Carolyn Jorgensen.)

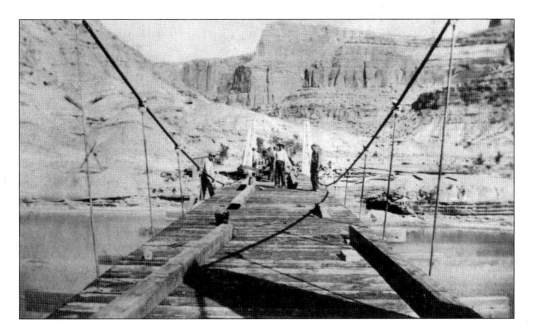

The main forces in a suspension bridge are tension in the main cables and compression in the pillars. Almost all the force on the pillars is vertically downward. The suspension cables are anchored at each end of the bridge, since any load applied to the bridge is transformed into a tension in these main cables. (Courtesy Ben Grimes.)

The Davis family attended the dedication of the Swinging Bridge in 1937. Kathleen Davis Rowley of Huntington is the baby in the photograph. The Davis Saw Mill provided all the lumber for the bridge. (Courtesy Kathleen Rowley.)

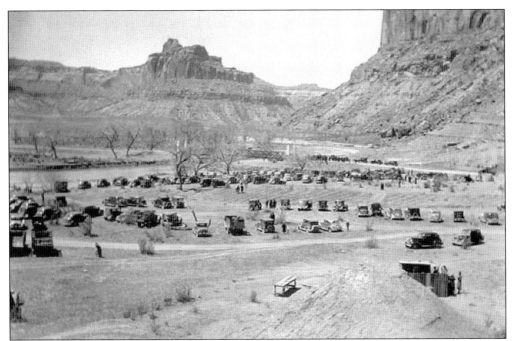

In 1937, the San Rafael Swinging Bridge was opened to the public. There was a huge turnout for the dedication. Cattlemen and sheepmen furnished barbecued beef and mutton. A band played and three young men from CCC Company 529 sang, Elmo Geary gave a reading, and Capt. Carlton Rockey and Louis P. Oveson spoke as local and state government officials. (Courtesy Denver Archives.)

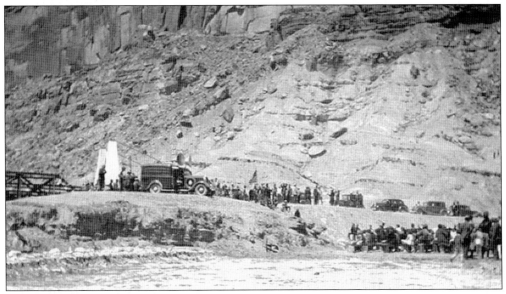

The newspapers read, "Hundreds attend dedication . . . and view for the first time the scenic marvels of Emery County's Mystery Land. . . . Before the construction of the bridge and the road through Buckhorn Canyon, it was impossible to travel except by horse or light rig. No car could make the trip." At the dedication, it was noted, "Busy stockmen can now take supplies to their men and herds in a few short hours where they had to spend days." (Courtesy Denver Archives.)

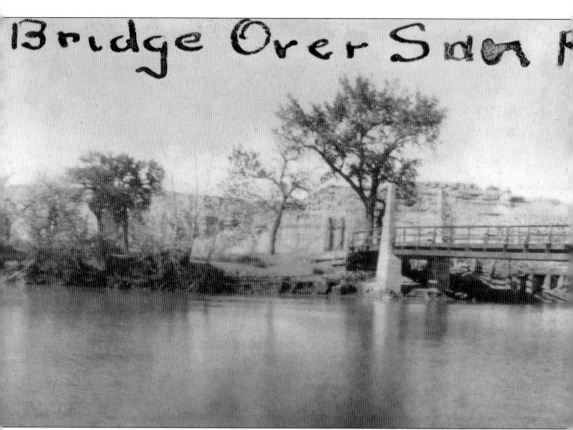

The San Rafael Swinging Bridge benefitted local ranchers by providing safe and convenient access to thousands of acres of winter grazing for their herds, and, as foretold at the opening ceremonies in 1937, "The bridge has been a benefit to generations yet to come." A new bridge has now been constructed to carry vehicles across the river, but the beloved Swinging Bridge is preserved as a

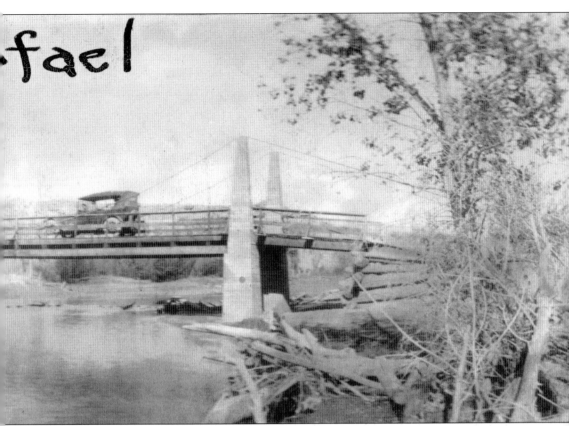

footbridge and is listed on the National Register of Historic Places. It was rededicated in 1997 after restoration work was done on this important piece of San Rafael history. (Courtesy Green River Archives.)

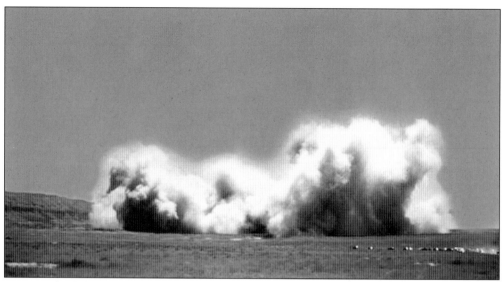

In 1948, the federal government sent military officials to the Swell to build a series of tunnels over a 300-acre area. Morrison Knudsen Corporation (MK) won the construction contract to blast the tunnels in the solid rock. It was a top-secret mission; not even local employees were informed about the reason behind the work they were doing. Over a period of four years, blasting was done to create tunnels in three different areas. Once the tunnels were made, 160 pounds of TNT was set off on top of them. The solid sandstone failed whatever the test was. Three craters were created by the explosions, and the work was stopped, military officials left, and crews pulled out of the area, leaving only the mysterious tunnels and craters behind. Local tradition now says that the government was actually looking to build the Nation Defense Center or NORAD in Utah's remote desert. The MK Tunnels, as they are now known, can still be seen in the San Rafael. (Above, courtesy Vernell Rowley; below, courtesy Ben Grimes.)

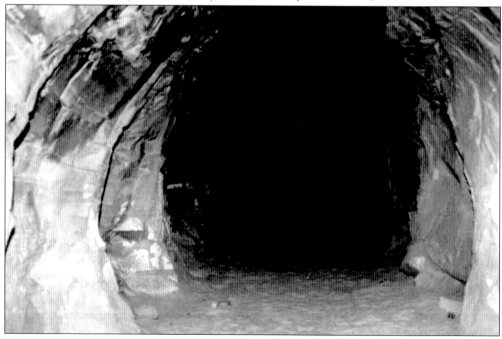

Bibliography

Baker, Pearl and Ruth Wilcox. *Castle Valley, A History of Emery County—Green River Section.* Salt Lake City, UT: Daughters of Utah Pioneers, 1949.

Baker, Pearl. *The Wild Bunch.* New York, NY: Abelard-Schuman, 1965.

www.CCCalumni.org

Emery County Archives.

Finken, Dee Anne. *History of the San Rafael Swell.* Moab, UT: Bureau of Land Management, 1977.

Geary, Edward A. *A History of Emery County.* Salt Lake City, UT: Utah State Historical Society, 1996.

Geary, Elmo G. "Dramatics in Castle Valley from 1875 to 1925." Master's thesis, University of Utah, 1953.

history.utah.gov

Seely, Montell, and the History Book Committee. *1880–1890 Emery County.* Castle Dale, UT: Emery County Historical Society, 1981.

Swasey, Monte C. *Oral History of Emery County Landscape.* Unpublished manuscript, Emery County Archives, 2000.

Warner, Matt, updated by Dr. Steve Lacy and Joyce Warner. *Last of the Bandit Riders . . . Revisited.* Salt Lake City, UT: Big Moon Traders Printing, 2000.

ACROSS AMERICA, PEOPLE ARE DISCOVERING SOMETHING WONDERFUL. *THEIR HERITAGE.*

Arcadia Publishing is the leading local history publisher in the United States. With more than 4,000 titles in print and hundreds of new titles released every year, Arcadia has extensive specialized experience chronicling the history of communities and celebrating America's hidden stories, bringing to life the people, places, and events from the past. To discover the history of other communities across the nation, please visit:

www.arcadiapublishing.com

Customized search tools allow you to find regional history books about the town where you grew up, the cities where your friends and family live, the town where your parents met, or even that retirement spot you've been dreaming about.